Charles Reid's WATERCOLOR SECRETS

Charles Reid, NA

NORTH LIGHT BOOKS
CINCINNATI, OHIO
www.artistsnetwork.com

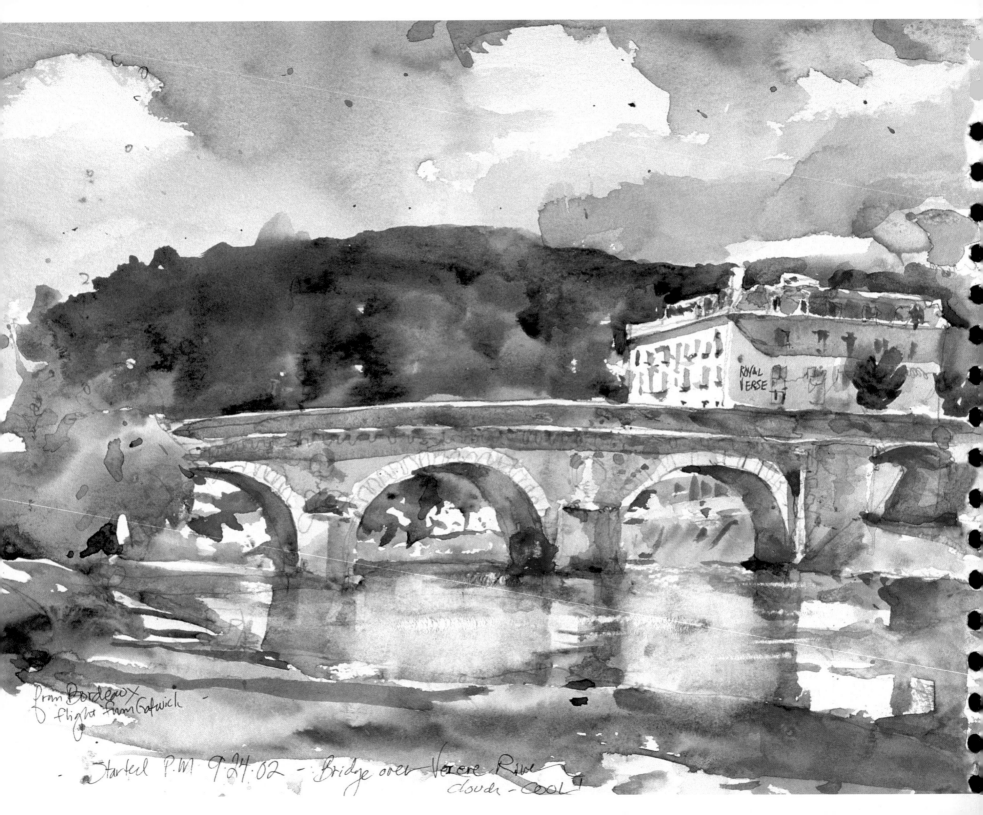

from Bordeaux
flight from Gatwick -

ROYAL
VERSE

Started P.M. 9.24.02 - Bridge over Verere River
clouds - COOL

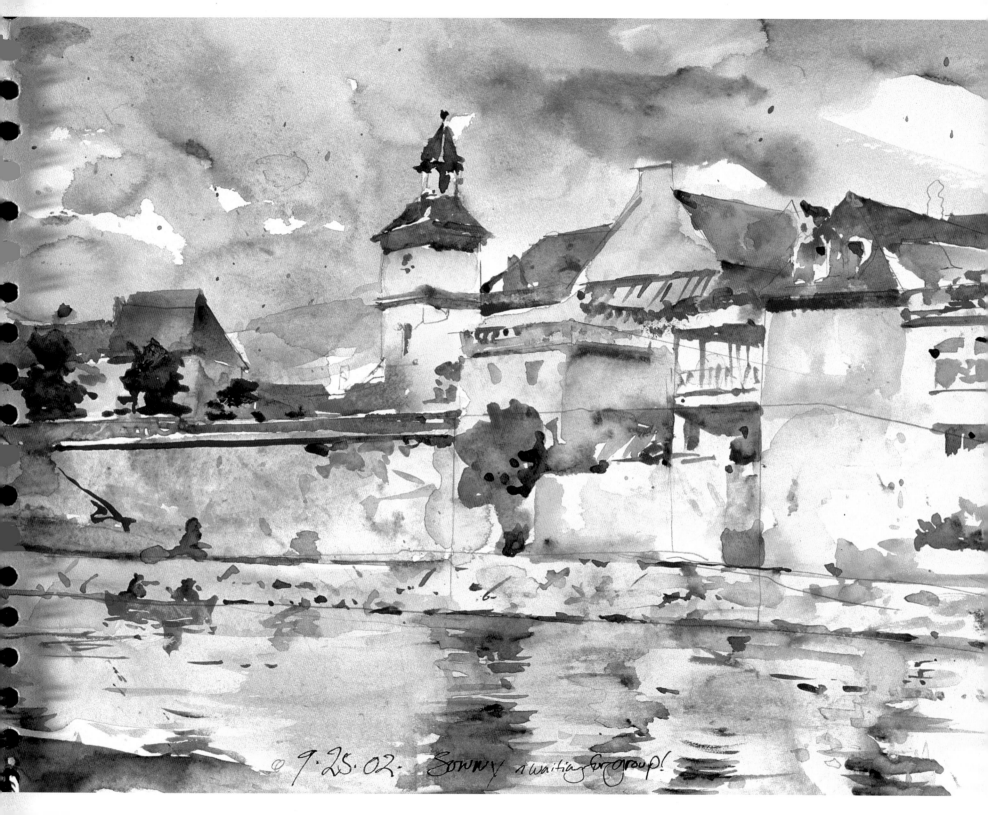

9.25.02. Sunny, awaiting for group!

About the Author

Charles Reid is an award-winning artist specializing in watercolor painting. He is a popular workshop instructor whose other books include *Painting Flowers in Watercolor With Charles Reid* (North Light Books), *The Natural Way to Paint* (Watson-Guptill Publications) and *Painting What You (Want to) See* (Watson-Guptill Publications).

Charles exhibits in both the United States and Europe. His paintings can be found in many private and corporate collections throughout the world. He is currently represented by the Munson Gallery in Santa Fe, New Mexico and Chatham, Massachusetts, as well as the Stremmel Gallery in Reno, Nevada. He is a member of The National Academy of Design and The Century Association. Charles lives in Green's Farms, Connecticut, with his wife Judy and their cat Brutus.

Acknowledgments

Thanks to my wonderful editor and cheerleader, Jamie Markle, the fine design talents of Wendy Dunning and the rest of the folks at North Light Books. Special thanks to my friend and excellent photographer Vin Greco who took the pictures for this book.

Charles Reid's Watercolor Secrets. Copyright © 2004 by Charles Reid. Manufactured in China. All rights reserved. No part of this book may be reproduced in any form or by any electronic or mechanical means including information storage and retrieval systems without permission in writing from the publisher, except by a reviewer who may quote brief passages in a review. Published by North Light Books, an imprint of F+W Publications, Inc., 4700 East Galbraith Road, Cincinnati, Ohio, 45236. (800) 289-0963. First Edition.

Other fine North Light Books are available from your local bookstore, art supply store or direct from the publisher.
08 07 06 05 04 5 4 3 2

Library of Congress Cataloging in Publication Data
Reid, Charles
 Charles Reid's Watercolor Secrets / Charles Reid.— 1st ed.
 p. cm
 Includes index.
 ISBN 1-58180-423-7 (alk. paper)
 1. Watercolor painting—Technique. I. Title: Watercolor sketchbook. II. Title.

ND2420.R43 2004
751.42'2—dc22 2003061530

Edited by James A. Markle
Designed by Wendy Dunning
Production art by John Langan
Production coordinated by Mark Griffin

METRIC CONVERSION CHART

TO CONVERT	TO	MULTIPLY BY
Inches	Centimeters	2.54
Centimeters	Inches	0.4
Feet	Centimeters	30.5
Centimeters	Feet	0.03
Yards	Meters	0.9
Meters	Yards	1.1
Sq. Inches	Sq. Centimeters	6.45
Sq. Centimeters	Sq. Inches	0.16
Sq. Feet	Sq. Meters	0.09
Sq. Meters	Sq. Feet	10.8
Sq. Yards	Sq. Meters	0.8
Sq. Meters	Sq. Yards	1.2
Pounds	Kilograms	0.45
Kilograms	Pounds	2.2
Ounces	Grams	28.3
Grams	Ounces	0.035

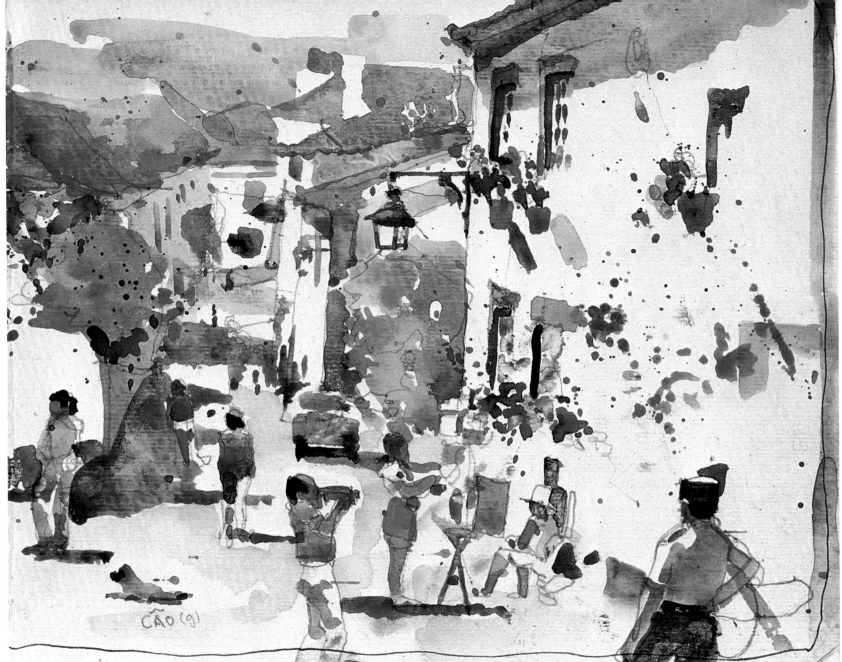

CÃO (g)

Near Sesimbra, Portugal

A sketchbook has the advantage over a camera—you can be selective
and paint what's important to remember.

Foreword

Why is it, when we're sitting or standing in front of our easel with a fresh sheet of watercolor paper staring at us, our thoughts are often, "I've got to make a great painting!"…and suddenly our fingers get a little stiff and our brain gets a little stiff and our spontaneity floats out the window? I promise you, the same thing happens in acting when the auditorium fills with people. And yet—at dress rehearsal the night before—we were "loose as a goose."

Charles Reid is my painting teacher. Last year he showed me the small sketchbook he always travels with, filled with little paintings. The looseness and spontaneity of those paintings were a revelation to me—not just because they were so beautiful but because within those small studies lay the secret to getting over the curse of having to make a "great painting" every time we put brush to paper. I recommend these "little paintings" to everyone.

G. Wilder

Gene Wilder, actor

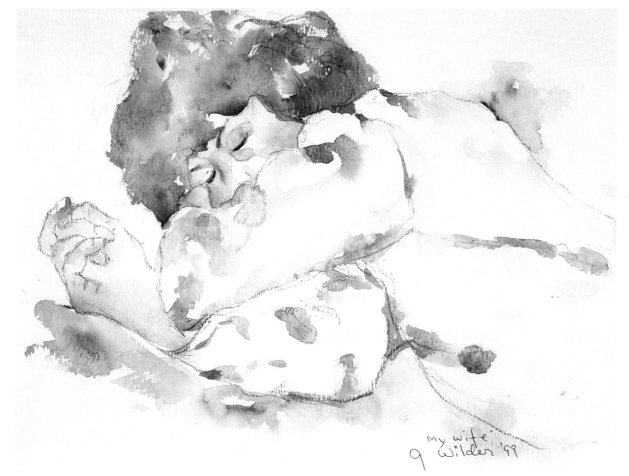

My Wife • *Gene Wilder*

6

To Judith, as always.

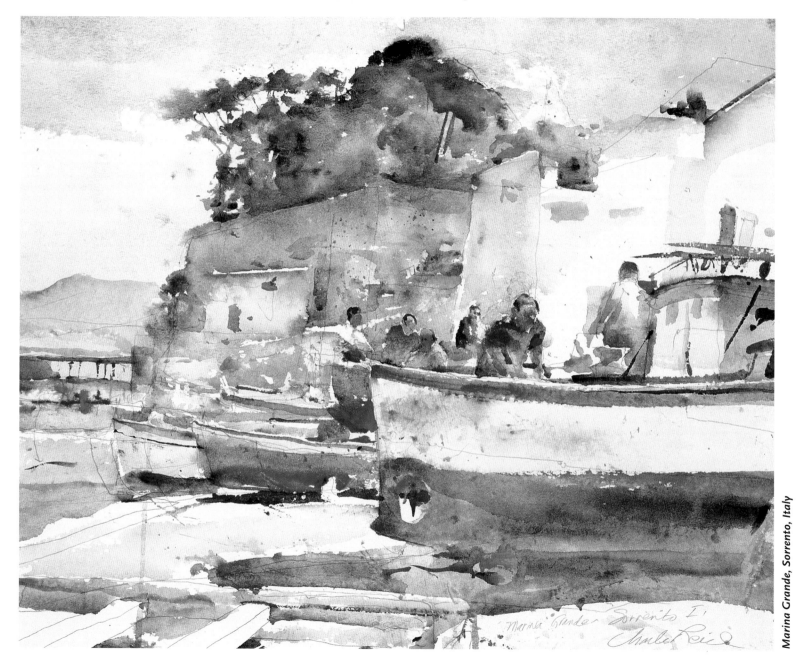

Marina Grande, Sorrento, Italy

Table of Contents

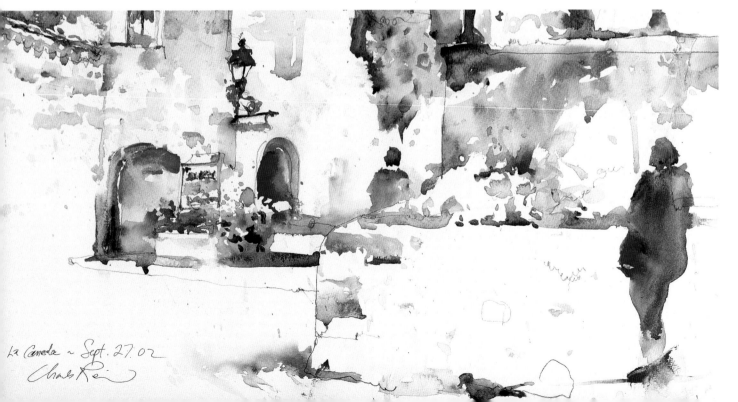

La Canada ~ Sept. 27. 02

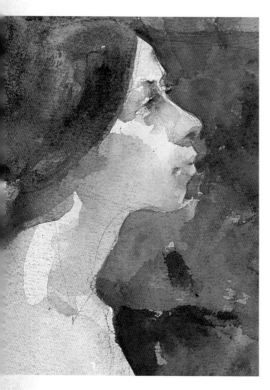

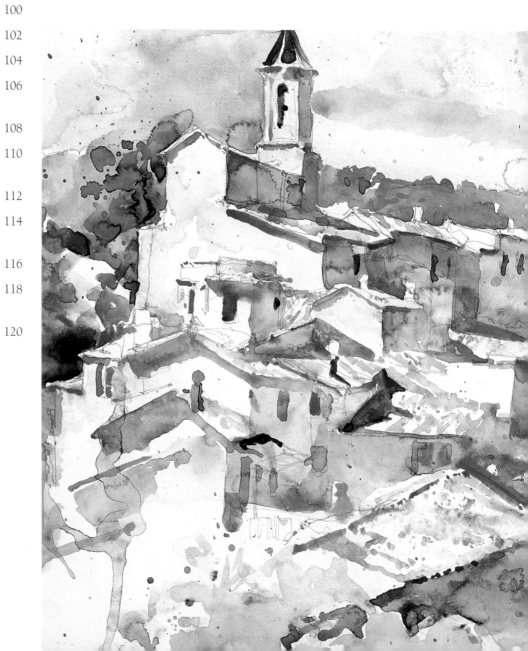

Introduction

As Charles has taught classes around the world, people have always been very interested in seeing his sketchbooks. He sketches for fun—wherever and whenever he can. You will see, by looking at the paintings in this book, that he enjoys doing "on-the-spot" work immensely.

In 2001, when we were in Florida, one of the class participants asked if he could buy one of Charles' sketchbooks. Of course, to us, they are without price and not for sale. I did think, however, that publishing some of the sketches from the books would be a great book idea. Charles agreed, as did Jamie Markle, his editor. Here they are!

Judith Reid

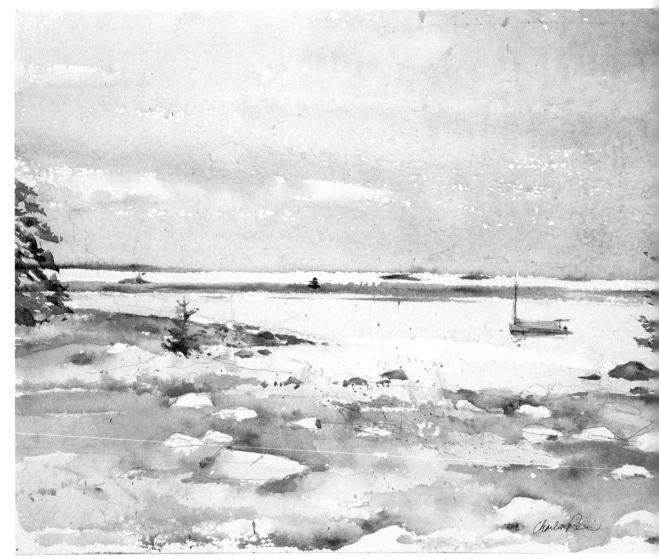

My Supplies for Sketchbook Painting

Most of the paintings in this book were done in sketchbooks of varying paper weights. Bound watercolor sketchbooks are hard to find—I currently use a spiral-bound sketchbook with sturdy watercolor paper from Art Xpress. The demonstrations were done on various watercolor blocks: Fabriano Artistico cold-pressed, Schut cold-pressed, Vivace, and Schut, flamboyant rough. No matter where you choose to paint or what materials you use, be sure you use quality art products from reputable manufacturers. All the skill in the world can't compensate for poor-quality paint, paper and brushes.

Suppliers

Any quality art supplier should carry the supplies I use or others that you can use to make your own watercolor paintings. If you can't find the supplies you want at your local art resources, you can try some of mine.

I purchase many of my art supplies from Art Xpress—sketchbooks, Holbein paints, Holbein plastic palettes with color wells, Fabriano paper and my brushes (www.artxpress.com).

I like Roberson travel brushes and Schut watercolor blocks. Schut blocks aren't currently available in the United States but can be ordered, along with travel brushes, from Cotswold Art Supplies, United Kingdom (E-mail: frameattree@aol.com).

My brass sketch box and brush holder come from The PaintBox Company (E-mail: c_young@watercolour.fsbusiness.co.uk).

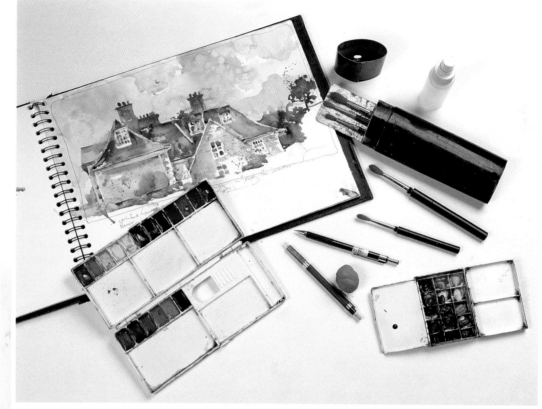

Travel Kit for Painting "On the Spot"

I use a gadabout folding chair from England and a painting umbrella, leaving behind an easel and preferring to work in my lap. Many art suppliers sell chairs and attaching painting umbrellas, which you might find helpful.

Starting clockwise from the lower left are the supplies in my painting kit: a plastic box including the colors I use by Holbein. This inexpensive box with a complete color selection is ready to go. A hard-bound watercolor sketchbook, 8½" x 11" (22cm x 28cm) or 11" x 14" (28cm x 36cm, shown here), a metal brush holder and cap, a bamboo brush holder rather than a cloth holder (which holds too much moisture), a squirt bottle to keep the paints moist, and Roberson sable travel brushes. I also use nos. 2, 4, 6 and 8 sable brushes, Series 77 Kolinsky. Isabey makes an excellent no. 6 pocket brush, but I find their Quill brushes to be too soft. I prefer Kolinsky sable brushes with a fine point over synthetic combination brushes. Your brushes are your most important investment—expensive—but most important. You'll also need mechanical or repelling pencils (.07mm and .09mm HB) and a kneaded rubber eraser. Never use a regular office eraser because it will damage the paper. I use the smaller paint box at the lower right for all of my sketchbook work.

Judith

Juds- Greenstown

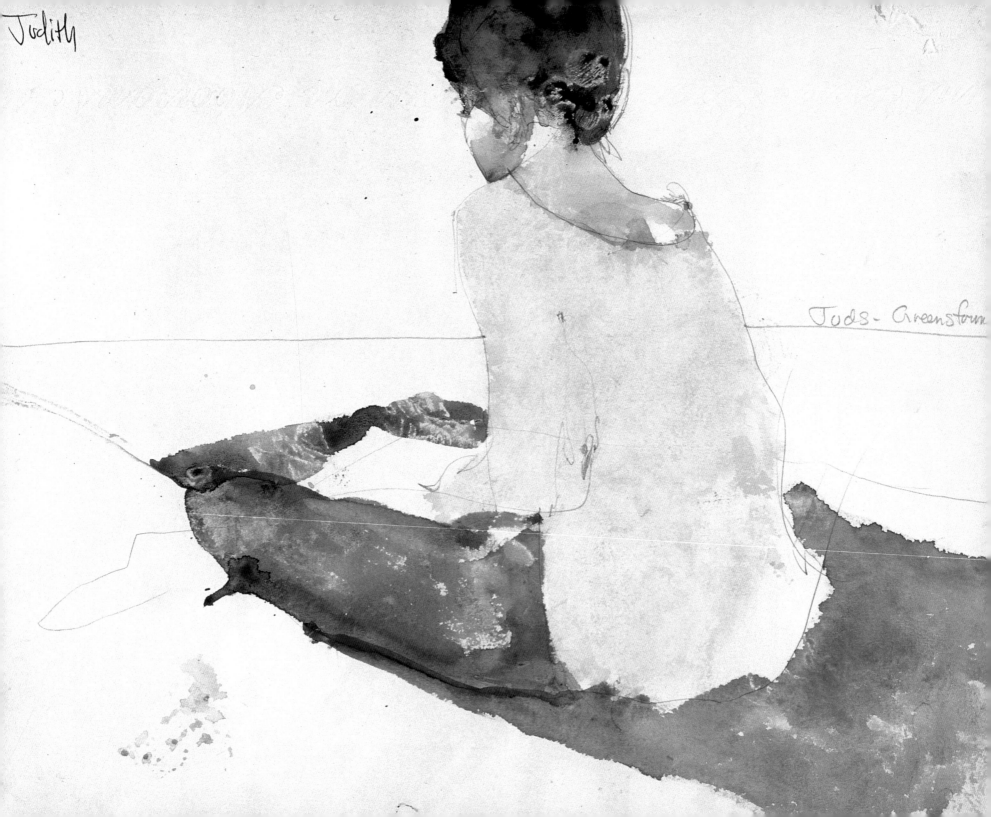

1 Early Paintings

I envy the simplicity of the early paintings in this chapter. I'd only painted in oil and had no training in watercolor, so I used the oil painting approach. I started by massing or generalizing my middarks and darks first, then working toward my lights and finding focus and specific details, keeping detail out in the light but keeping my darks simple, with a minimum of tonal-value changes.

You'll see that I've used a limited, almost monochromatic palette in these early paintings. With the exception of *Bob's Model* and *Perry*, all of these were painted with backlighting or in flat lighting. As you look at the paintings, notice that I simplified my shadows so they are essentially one tonal-value with minor variations. Then I painted my lights with great care and precision. Your darks should be general and close in tonal-value but your lights, where they meet your darks, must be precise with exact accuracy of shape. Andrew Wyeth is a master at this; his watercolors are a marvelous study of large, general, simple darks with small bits of exquisitely detailed light shapes.

Judith Reid—Local Tonal-Value

Local tonal-value is the intrinsic darkness or lightness of an area in relation to its neighbor. Local value-color usually dominates light and shadow in darker values. For example, a black shirt is still a black shirt even under a strong light. Local value also dominates in areas of strong color—a red shirt should still be a red shirt even under a strong light. Local value areas shouldn't be flat but should have close-valued textural variations.

I stressed simple, large local-value shapes and ignored light and shade except for careful light and shadow shapes in the face and upper back. I contrasted simple, large shapes with small areas of nicely defined detail. I tried to connect as many shapes as I could, leaving only the hair, lower face and the lower shirt isolated.

Juds—Green's Farms

Squinting to See What's Important

Flat lighting helps you simplify. If you don't have a model, set up some objects in front of a window without a strong interior light. Squint very hard and see how objects and shadows merge without apparent boundaries. Still squinting, do you see any object that's clearly darker or lighter than the thing behind it? All boundaries that are hard to see when squinting should be lost. All boundaries that are apparent when squinting should remain.

Exercise

Leaving Backgrounds White

If you're a beginner, don't worry about color and backgrounds; leave backgrounds the white paper if in doubt. Before going on, try copying Juds *(page 12) and* Bob. *Try to draw slowly with a single line and concentrate on angles and shape. You'll notice that both drawings have more angles than curves. Next, make a simple local-tonal copy of* Juds *and then paint* Bob, *concentrating on one-third found and firm edges and two-thirds lost and blurred edges.*

Squinting Creates Connections in Paintings

Bob uses the same limited palette as *Juds,* but I have added pure Cadmium Red to the collar and Cadmium Yellow in the brush area. The big challenges are to cross over from the hair into the eyes and nose and let the sweater merge with the trousers. First, squint and find important separations where you'll need to save some hard, dry boundaries—light on the cheek, fingers and collar. I try for one-third hard, separated boundaries and two-thirds lost or blurred boundaries.

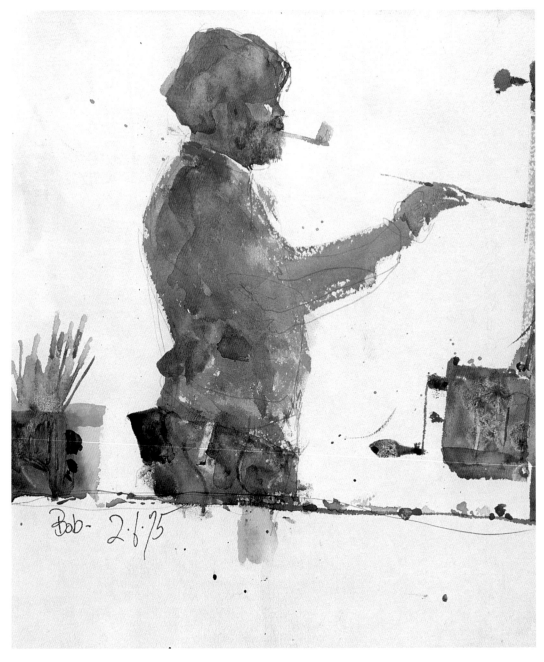

Bob

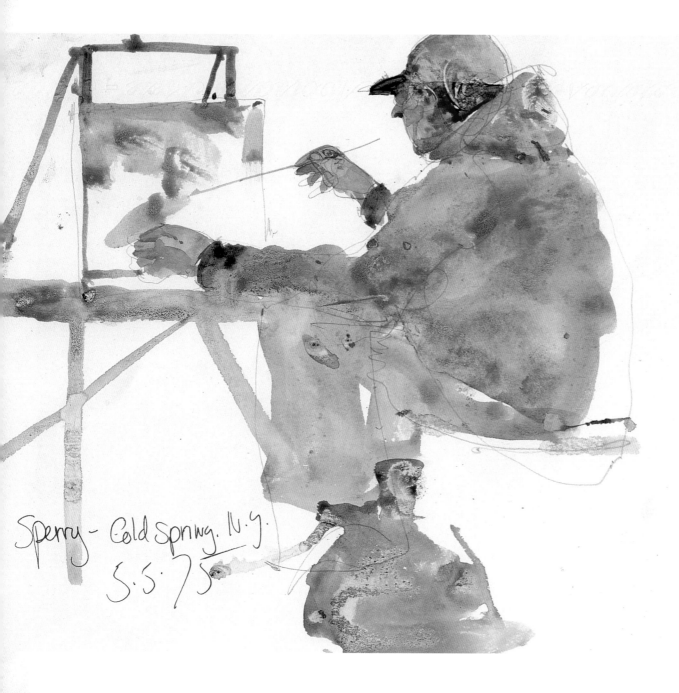

Sperry - Cold Spring. N.Y.

S.S.75

Color

My early paintings are quite monochromatic. I was interested in shapes, edge control and local value—the keys to successful painting. Choosing the right color isn't essential.

Painting People in Flat Light

This was painted on an overcast day, so there is no discernable light and shade. When I squinted, Sperry and his easel became a simple silhouette of partially connected mid-dark tonal-values. There were two exceptions. The first was Sperry's hair and jacket hood. I scratched a connection in the wet paint with my fingernail to connect the hair and hat to avoid an awkward triangular hair shape. The second exception was the socks and cuffs. Making them dark creates an area of strength to balance the importance of the head and easel.

I drew Sperry with hunched shoulders, his painting hand held far up the brush handle, with his left hand reaching toward his painting. A lot of care was taken in the drawing and painting of the outside shapes. I wanted the viewer to see Sperry's silhouetted gesture, not where the parka ends and the trousers begin. Look for the two-thirds lost or blurred boundaries and one-third found boundaries within the composition.

Sperry Andrews—Cold Spring Harbor, NY

Flat Light Versus Direct or Spot Light

A strong, single light makes the light and shadow shapes easy to see in this painting. Understanding them when looking at the actual model, however, can be more difficult. Force yourself to simplify shadow shapes into single tonal-values with only minor variations. If you try to paint all of the subtle tonal changes you see, your shadows will be patchy and confusing.

Paint the Figure First, Face Second

If you're having trouble painting the face, try not to fuss and go on to the rest of the figure. With watercolor, you can't correct the face, even with heavier paper that is still damp.

Painting With a Single Light Source

Painting a person in flat lighting is very difficult; a single light source makes the job much easier. You should be able to see obvious planes of light and shade. Squint and think of painting the light rather than painting the person. I painted Ann under diffused lighting, but without apparent light and shadow I couldn't get Ann's face right and scrubbed it out. Corrections are impossible on light sketchbook paper.

Ann Painting, Studio II

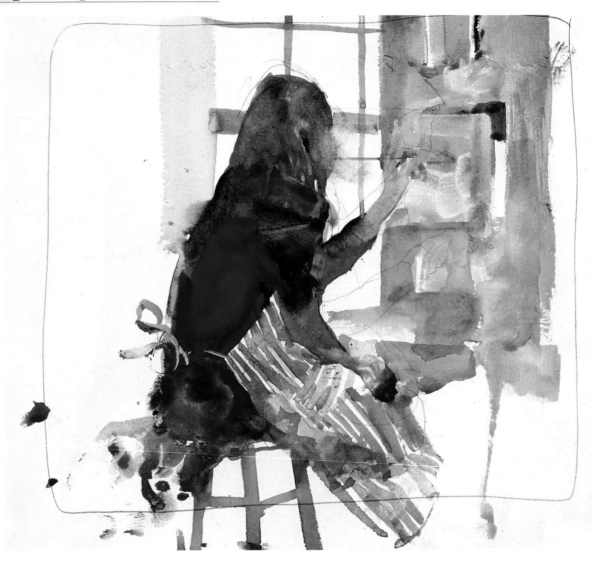

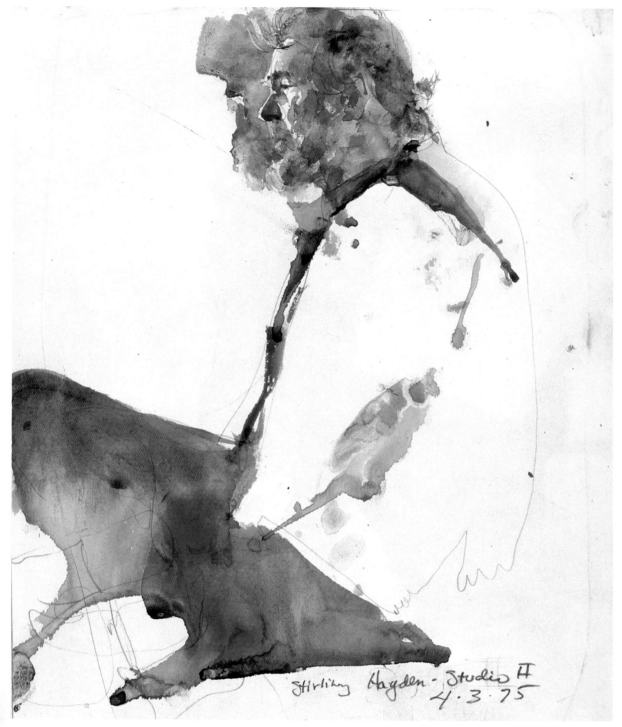

Stirling Hayden - Studio II
4·3·75

Plan the Painting With Pencil

Try drawing the boundaries of your shadow shapes using a single light pencil line. Always start your shadow shape where it meets the light—painting from the light into shadow rather than painting from shadow toward the light. Starting your shadows where they meet the light helps you to keep a more precise shadow shape boundary.

If you're new to figure painting, keep your shadow shape edges firm where they meet the light; if you try to soften them you might have mushy shadow shape boundaries. Be able to see and draw accurate shadow shapes, then worry about softening them.

Unite the Hair and Face

Make sure you incorporate the hair with the face. Don't paint them separately. The hair and beard are part of my shadow shape. Boundaries are usually soft and lost in shadow areas.

Stirling Hayden, Studio II

Creating Form Using Silhouettes

You must be able to see and draw accurate silhouette shapes. If a light silhouette is essentially light, keep the shadows definite but high key so you don't destroy the essential lightness of the silhouette.

Dark backgrounds need warm and cool color changes. Never use homogenized "puddle color." Try mixing on the paper. Use plenty of pigment and a modest amount of water, working for color changes with similar tonal-values.

> "Everything in painting is a matter of silhouettes."
>
> *Hawthorne on Painting, Dover Press*
>
> ❄

Paint With or Away From the Form

Painting with the form means that your background color stroke is painted parallel to the image. Painting away from the form means that your background color stroke is painted away from the image. Never outline a lighter image with a continuous strip of dark paint that isolates your model. Paint with the form where you want definition; paint away from the form where you want your model to escape a bit into the background. This is a high-keyed portrait against a dark background. The model needs a light, single-valued shadow shape. Always start your shadows around the eyes and nose, where you want definition and character.

Bob's Model, Studio II

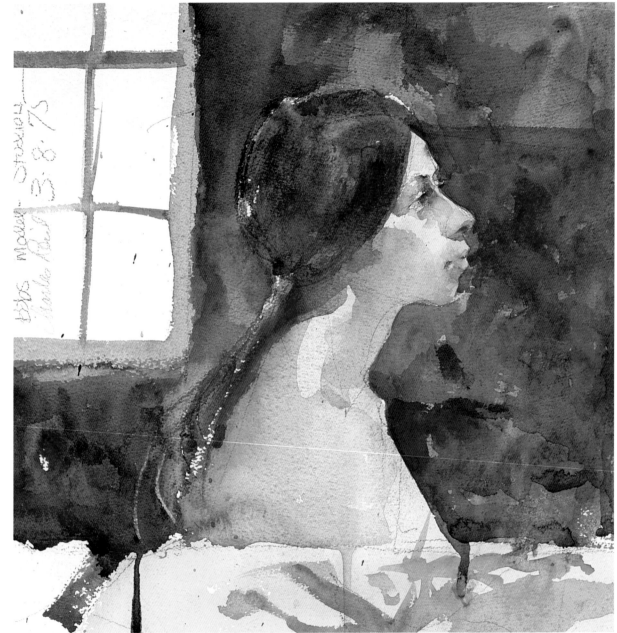

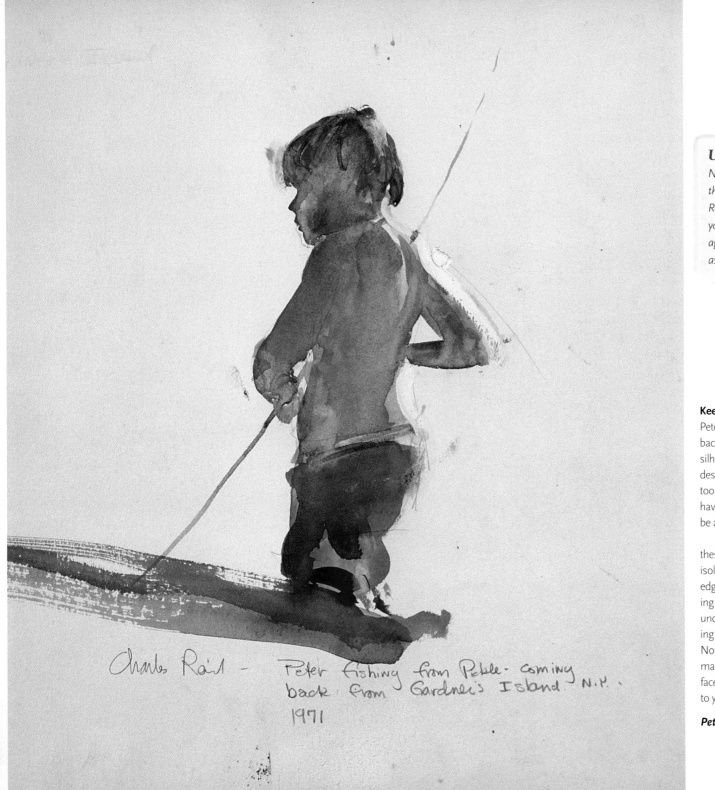

Charles Reid – Peter fishing from Pebble- coming back from Gardner's Island. N.Y. 1971

Keeping Your Lights Clear

Pete is a mid-dark silhouette against a light background, I wanted to keep the identity of the silhouette. Bits of light within the shadow can destroy the simplicity of the silhouette. If you see too many subtle lights in your shadows, you'll have confused tonal-values and it will no longer be a dark silhouette.

The main light strikes the upper back. I left these lights the white of the paper then carefully isolated them with my shadow color using firm edges at the shoulder blades, with a slight softening into the upper back. Always make sure you understand where your main light source is coming from and where it is striking your subject. Nothing in shadow should be as light as your main light. Reflected light in shadow (on Pete's face) helps give form, but it should be secondary to your main light.

Pete Fishing

Edge Control

Eric is monochromatic, so we don't need to worry about color; instead we'll concentrate on edge control. Edge control is seeing where you should leave a hard edge and also where an edge needs to be softened. Plan ahead—edges must be softened immediately. Trying to soften edges when they're dry will only work on a heavy, durable paper, like Arches. Softening dirty edges usually causes a grainy, mushy, overworked look.

Painting Edges in the Hair and Face

First paint the face color well into the hair and beard. Let the face dry before adding adjacent hair where you see a definite edge of contrasting value. For edges of hair that merge with the face, use lots of paint, wet-in-wet, and paint the hair and beard. This takes practice and the right paint consistency. It won't work if you have too much water or dried paint.

Determining Where the Face Ends and the Hair Begins

Don't paint the face as a separate shape, leave white paper to fill in the hair and beard later. Squinting will show where you need a separation between the hair and face. Never paint around or separate physical identities unless you see tonal-value contrasts.

Eric

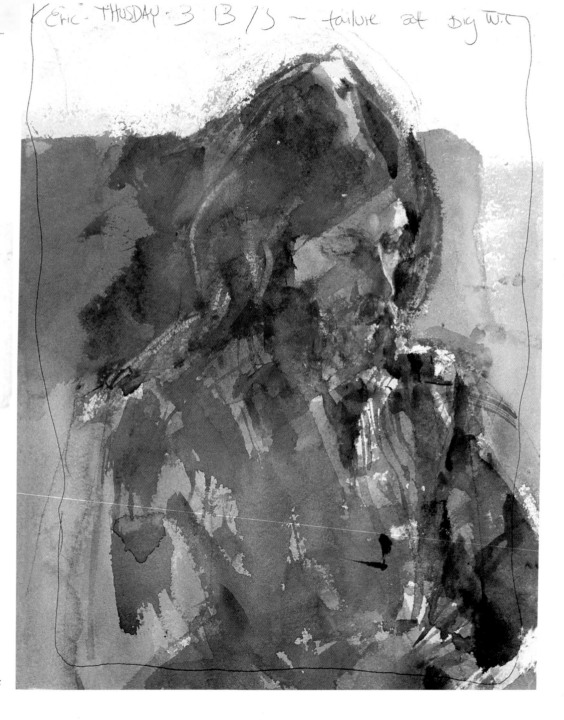

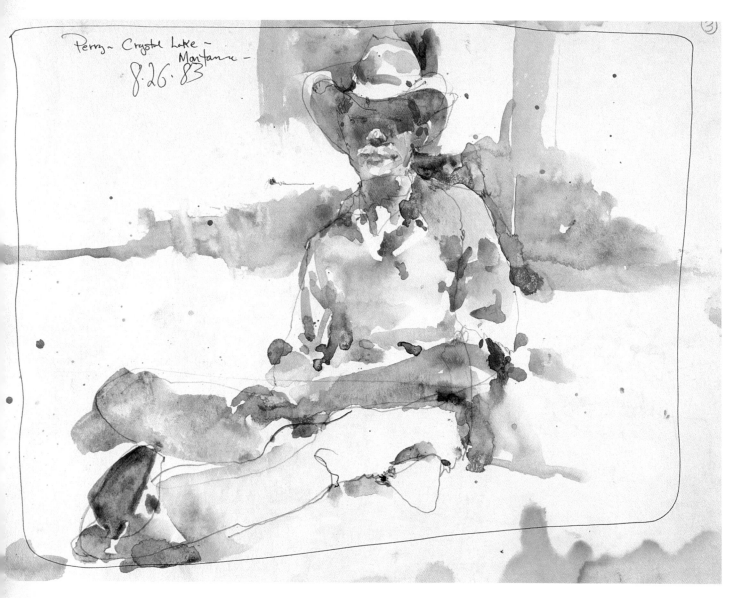

Perry~ Crystal Lake ~
Montana ~
8·26·83

Painting Objects in Bright Sunlight

Perry is out in the sun. I was taught that a subject's shadow shapes in outdoor sunlight will be one tonal-value lighter than a subject's shadow shapes painted indoors. Compare the tonal-value in Perry's shadow shapes (under the hat) with Eric's shadow shapes. My lights in *Perry* are washed out with parts of the white paper left untouched. I've ignored the general tonal-value rule: A subject's local color-value out in the light shouldn't be washed out but should always retain its unique color-value identity. Breaking the rule: The treatment of your figure should reflect your treatment of the surroundings. When you have a lot of white paper in the surroundings, you should leave some white paper in the figure. When you have a dark background, you should keep the dark shirt's local tonal-value light in comparison to the dark background.

Perry is sketchy and fragmented compared to the more finished *Eric*. It was a time consideration—Eric was being paid and was comfortably posed while Perry was uncomfortably sitting against a wooden post in the sun. The drawing was done quickly with an incomplete single line for the figure, but the silhouette of the hat, face and contours of the shadow shape under the hat, side of face, underplanes in the nose, mouth and chin were carefully drawn. Think of the shadow shape as one connected form with minor value changes. No value within shadow should be as light as your main light.

Perry, Crystal Lake, Montana

21

Building Your Painting's Foundation With Shadows

Your shadow and cast shadow shapes will be your picture's foundation. Shadows should be very close in tonal-value, but colors should be varied and mixed directly on the paper. Avoid overmixed palette colors. Think of your shadows as color swatches of warm and cool paint mixed on the paper. I used Alizarin Crimson, Cobalt or Cerulean Blue and Yellow Ochre or Raw Sienna. Try for a mid tonal-value with warm and cool variations. Your color changes mustn't go too light or too dark. You're trying for very close values with color changes.

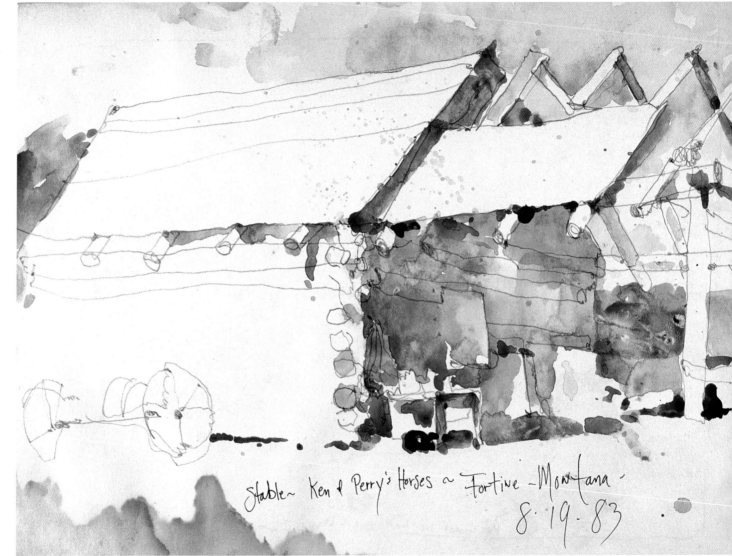

Stable~ Ken & Perry's Horses ~ Fortine ~Montana~ 8·19·83

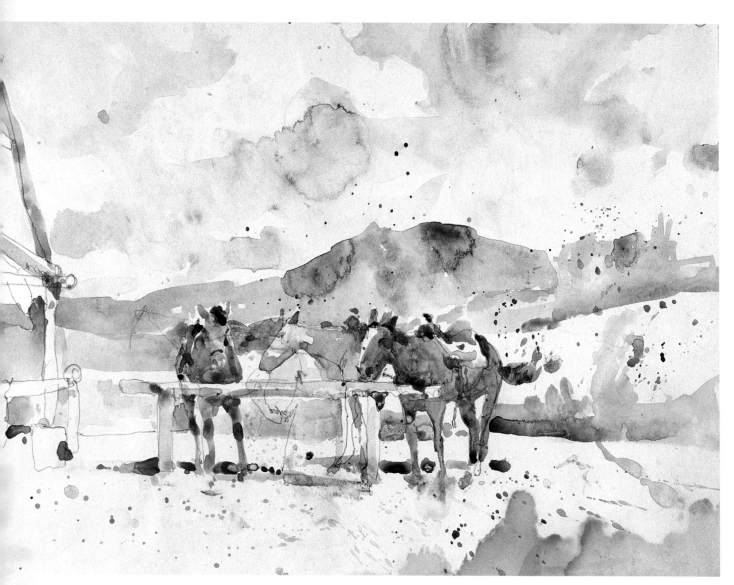

Vary finish, edges, values and color intensity throughout your painting.

❋

Begin With Your Darks

When short of time, always start with your darks, leaving your light values the white of the paper. Even if I had time, I'd avoid painting the light parts in the roof and rafters. The shadows are too high key and subtle and would be lost with toned lights. Instead of painting the light parts, paint the negative background color behind them. The horse on the right is finished with darker local-value and is a more finished smaller, darker form to balance the larger, sketchier building.

Stable—Ken and Perry's Horses, Fortine, Montana

23

Adjusting Tonal-Values

Don't automatically lighten an area if it appears too dark when wet. A dark value keeps its initial value and color if you are using a little water and a lot of paint; with even a little more water you'll lose two values and your color intensity. Leave white and very light tones the white of the paper. Add subtle light tones at the end of your painting session when you'll be able to judge them accurately. Try to be decisive in your light, middle and dark areas. Keep their overall value identities. Don't find lights in your darks and darks in your lights. Don't find lights and darks in your midvalues. The less complicated your values are, the better off your painting will be.

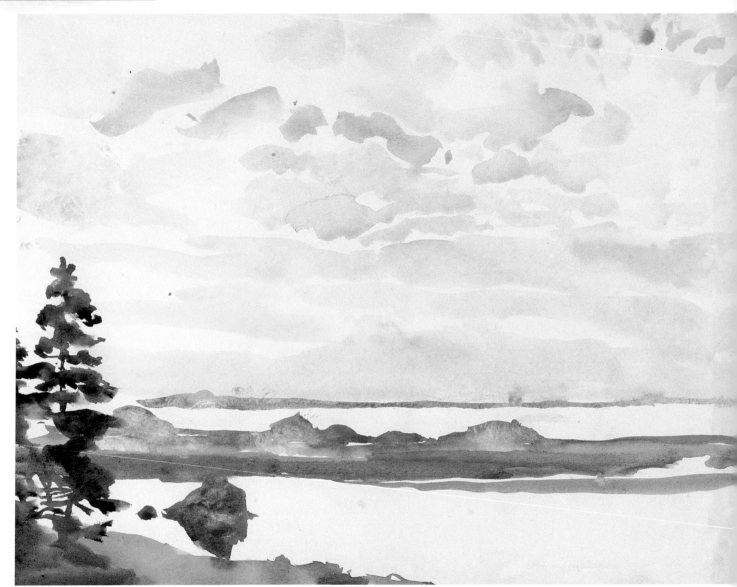

Don't find lights in
your darks and
darks in your lights.
The less complicated
your values are, the
better off your
painting will be.
❋

8·12·78

After I got up to get him off fishing with Gordon & David on Alfred's boat - 5:45 ~ July asleep so Sam & I sit out in front and watch for Alfredo blue boat - Great Sky!

Determining the Tonal-Values

The water seems to be a mirror with a tinge of bluish gray so it's best to keep it white paper. The spruce is dark with some minor lights, but I felt I needed a dark to stress the feeling of backlighting. The rock was a good place for a spot of near-pure color. I think I made the mid-valued stripe of land too busy, and a little too much water made spots of too-light, washed-out paper.

Early Morning—Baccarro, Nova Scotia

Capturing Accurate Shapes

Accurate shapes are as important as good tonal-value. Paint dark shapes against the light and light shapes against the dark with precise care. Lights against darks and darks against lights usually have relatively firm boundaries but shouldn't look like cutouts. Sometimes, keep hard edges in your silhouette shapes but vary their values. Some boundary shapes will have more contrast with their neighbor (incompatible adjacent values), while others will be close in value to their neighbor.

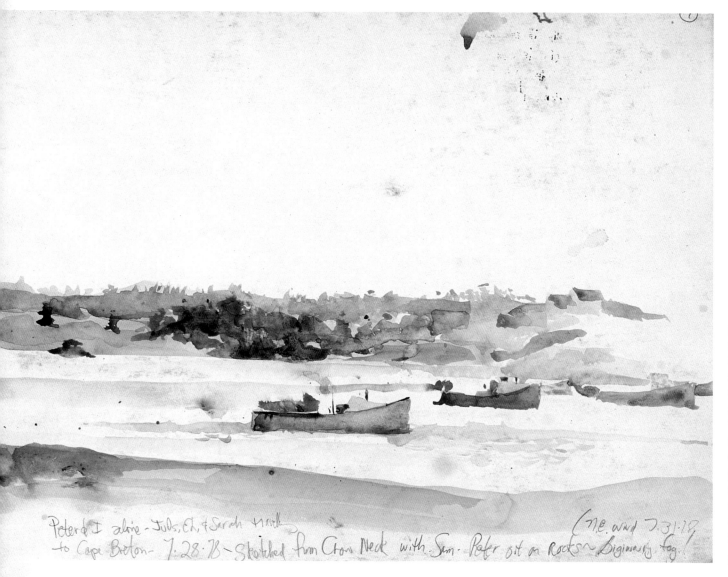

Peter & I alone - Jubs, Eh, & Sarah North to Cape Breton - 7.28.78 - Sketched from Cross Neck with Sam - Peter out on Rocks - Beginning Fog (N.E. Wind 7.31.78)

Accurate shapes are as important as good tonal-value.

❈

Practice Patience to Perfect the Painting Process

Patience and timing are important—don't be in a hurry. I used mostly hard edges here but tried to get my separations and connections with compatible and incompatible value relationships. You must wait to make sure you have dry paper where you want firm edges. I can't remember my colors, but it looks as if I mixed most of my greens. Try mixing your own greens. Use Cobalt and Cerulean Blues (Ultramarine would be too dark for this high-key painting) and various yellows such as Cadmium Lemon, Cadmium Yellow and Cadmium Yellow Light.

Harbor With Pete

27

Direct Painting:
A Snowy Landscape

I want to show you how I mix paint directly on the paper and how I go for the best tonal-values right from the beginning. Some correcting is inevitable as your tones dry, but you should always go for a finish with your first effort.

The Basics
Concentrate on shape, good tonal-value on your first try and losing boundaries when two similar tonal-values meet, regardless of object identity.

I have clear separations of tonal-value, from white paper to middle tones to darks. Make sure you have a clear separation of tonal-values; never have a painting that has all middle values with a few darks thrown in at the end. The best painting has the fewest shapes —the more shapes you have, the better painter you must become.

MATERIALS

Pencil
Mechanical or repelling pencils (.07mm and .09mm HB)

Brushes
Nos. 2, 4, 6 and 8 sables

Paints
Burnt Sienna • Burnt Umber • Cadmium Orange • Cadmium Red Light • Carmine • Hooker's Green • Ivory Black • Raw Sienna • Raw Umber • Ultramarine Blue • Viridian

1 Draw
Complete a contour drawing of the subject you wish to paint. Keep the pencil on the paper and draw a single line with dots, stopping to check on angles, direction and the distance the pencil must travel. Always make a picture boundary so you'll know how much space you'll need around your subject. The best rule is to crowd your subject within your picture boundary, so you will be sure to fill the picture plane.

2 Record Your Colors and Begin Painting
Make some color swatches outside your drawing to record the colors you're using but more importantly to remind you of how much pigment you need to manage a dark tonal-value for a particular passage. Have a piece of watercolor paper next to your painting to check your color tonal-value consistency before you paint a passage.

Start with Ultramarine Blue and Raw Umber mixed wet-in-wet on the paper. Let some of the color leak out to the right of the house where there will be darker trees. Maintain some edges next to some lighter adjacent shapes but also cross over some edges with darker or similar-valued neighbors.

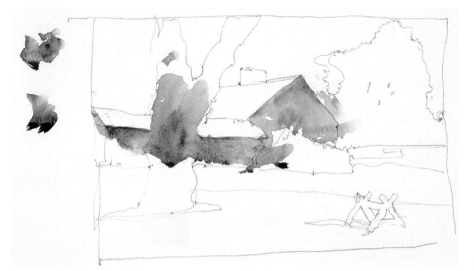

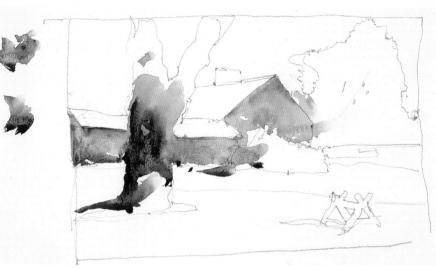

3 The House, Tree and Bush
The house, tree and bush are all similar in value, so begin by painting the house; go through the tree and into the bush all at once. Use Hooker's Green and Ivory Black in the bush and Burnt Sienna, mixed on the paper with Ultramarine Blue, in the tree.

4 Paint the Tree and Cast Shadow
Add Burnt Umber to the tree with Ultramarine Blue for the tree's cast shadow and the cast shadow next to the bush.

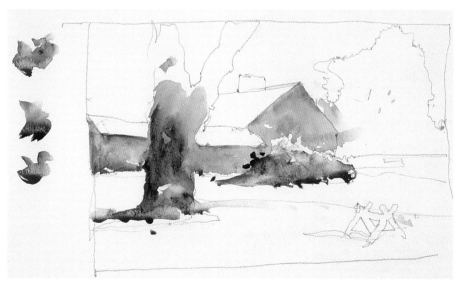

5 Paint the Tree Trunk and Bush
Add more Ultramarine Blue in the tree trunk. The bush consists of Ultramarine Blue, Raw Sienna, Carmine, Hooker's Green, and Ivory Black, mixed on the paper wet-in-wet. Use the black with a little water at the bush's base so it will seep into the other colors. You should have your board at about a thirty-five degree angle.

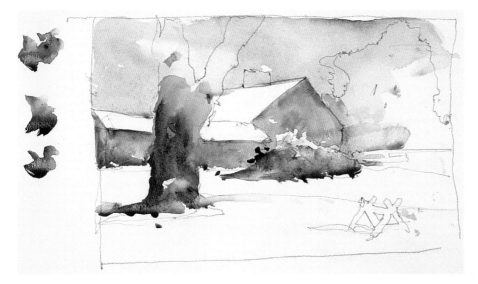

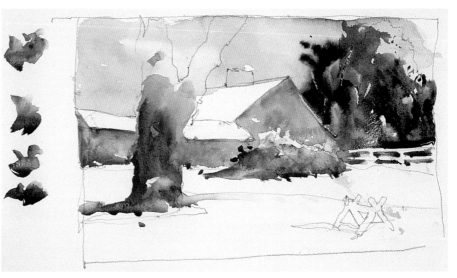

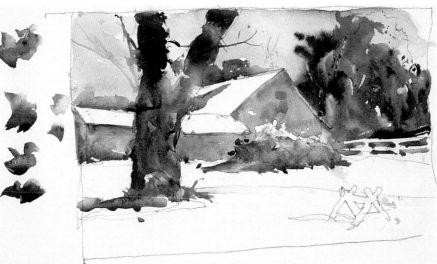

6 Paint the Sky

Paint the overcast sky with Ultramarine Blue, Raw Sienna and Carmine. This combination should be mixed on the palette's mixing area. It's OK to have a homogenized mix. Paint over the tree trunk, chimney and the tree mass to the right of the house with this sky wash.

7 Add the Green Trees

While the sky color is still wet, apply Ivory Black, Hooker's Green and Raw Sienna for the tree mass to the right of the house. Keep a firm, lateral base but paint the tree mass with little water and thick pigment. Use some of the background tree color to paint negative see-through shapes to form the fence.

8 Add Definition

You'll have to work quickly—don't stop to separate physical shapes of similar tonal-value. Slowing down, and being very careful, save your light shapes by going back in and lifting. One part of the tree trunk is painted with Ultramarine Blue and the other with Burnt Umber—never paint adjacent parts with the same color. Place Viridian next to the Cadmium Red Light chimney and allow the colors to merge, painting wet-in-wet. Use Raw Sienna to define the rooftop on the left and bits of Cadmium Orange around the tree base.

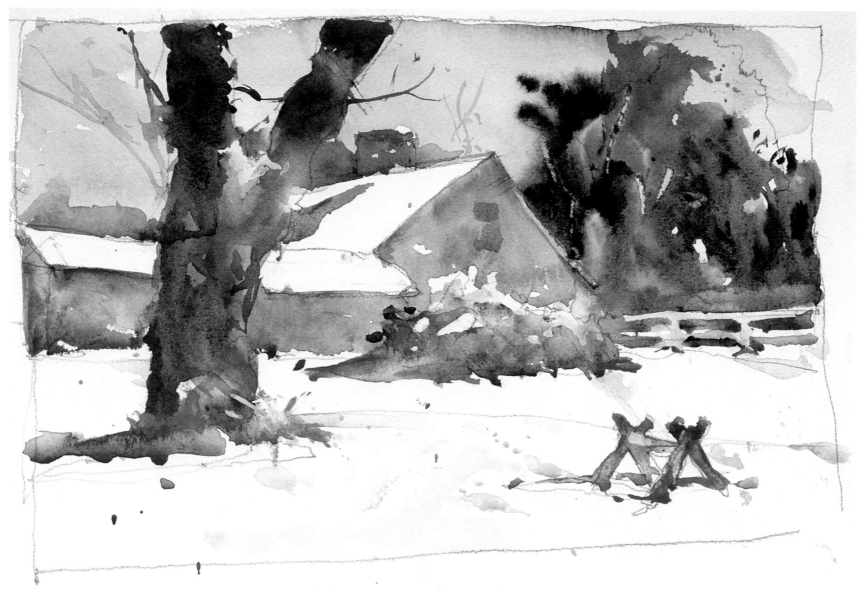

Finish

I painted many versions of our house from my studio window, some better than this, but I never go back with hopes of improvement. Most paintings have their failure or success set about one-half to three-quarters of the way through. I added a sawhorse but wouldn't try to make corrections—it's better to make a new painting.

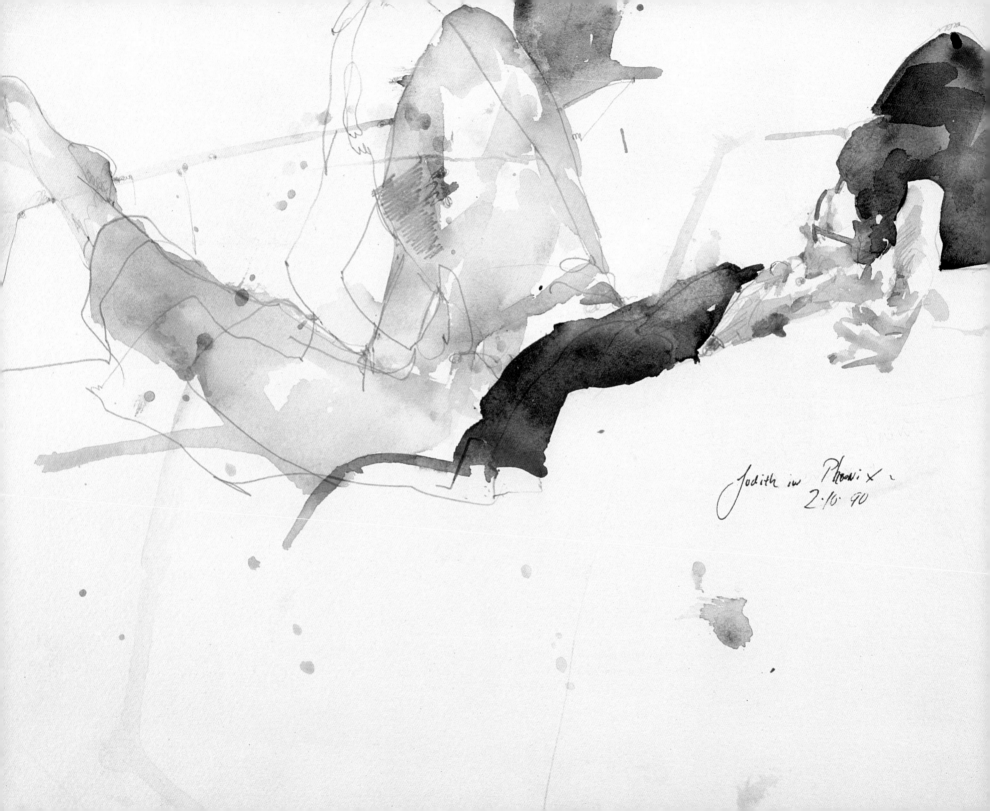

Judith in Phoenix.
2.10.90

2 | People and Figures

Although these paintings were done for fun, usually with my sketchbook on my lap, I've had years of practice. Painting people is a daunting prospect for beginners. First, you should become comfortable with watercolor—practice the amount of water you need in relation to moist paint (you should be able to pick up pure pigment on the tip of your brush from the paint supply). It is a good practice to make color swatches that match the color and tonal-value (especially the middle to dark values) in the paintings in this section. Practice mixing your color on the paper—I do very little mixing on my palette. Concentrate on painting the shapes of light and dark rather than rendering features. Finally, practice a single line, rather than a sketchy, broken line, keeping your pencil in contact with the paper. I use the same principle in my brushwork: Put the brush tip to paper, press down to the brush's midsection and paint, keeping the brush moving without lifting until the passage is complete. This process is thoroughly covered in the beginning sections of *Painting Flowers in Watercolor With Charles Reid* (North Light Books).

Use the Magic Triangle

This composition shouldn't work, Judy's foot and knee are leading out of the painting, but the dark, compact local-value shapes makes the placement of the shapes unimportant. This composition relies on the magic triangle—three dominant colors or local-value shapes form a triangle within the picture. You usually want two of the shapes near two of the picture boundaries and the third shape near a third boundary or closer in from the picture's edge. The dark shapes anchor the composition and make it work. Without the dark values in the arm and hair on the right, the left pant leg, and the area above the knee in the center, this painting would float off the page. The triangle secures the image to the paper and keeps the eye from wandering out of the painting.

Judy in Phoenix

Using Color in Your Paintings

The magic triangle is a good starting point, but often you'll need to use more than three dominant shapes in your paintings. Intense-colored shapes can be equal to dark local-value shapes. Try to have some areas of almost pure, unmixed color along with areas of more neutral color. Don't be afraid to use paint straight from the tube. Use as few colors as possible, while trying to keep warm and cool passages throughout your picture. Remember not to use old puddle color from your palette. Make sure that every area has an escape route where one or two spots in adjoining areas are blurred.

Mixing Color on Your Paper

Try mixing color on your paper with just a little working out of individual colors on your palette. The less mixing you do on your palette the cleaner and clearer your color will be.

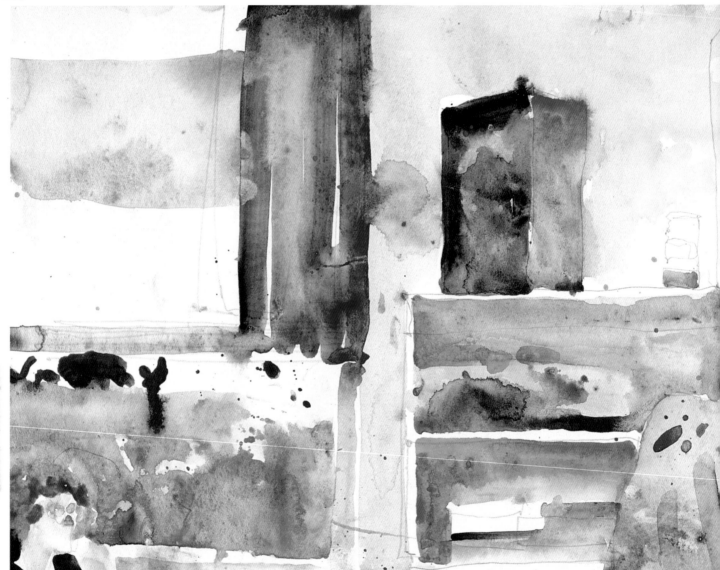

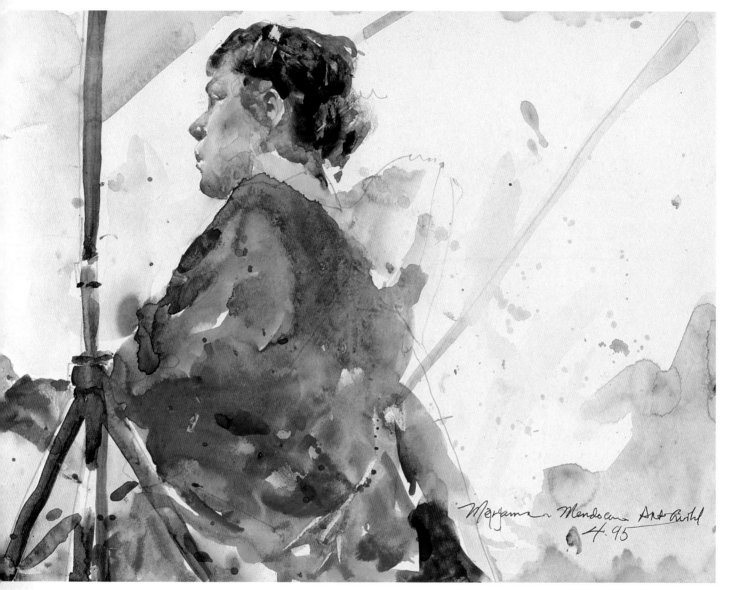

Try to have some areas of almost pure, unmixed color along with areas of more neutral color.

❊

Using a Variety of Colors

In *Mariana*, I used warm, cool and neutral colors—a violet with some Cobalt Blue (cool) and Cadmium Red (warm)—with diluted Ivory Black (neutral) in the light stand. Her head has warm, cool and neutral blacks along with Raw Sienna in the hair. Black and red were used for the box on the bookcase next to the almost pure Cobalt Blue drape. I dropped a spot of Cadmium Orange and a bit of diluted black on the left side of the drape and then released some more into the window.

Mariana, Mendocino

Carefully Observe and Draw Your Models

Skill in drawing and painting takes time to develop, and seeing shapes takes even more time. When drawing from a model, never draw from your imagination or conception of a person. You'll need to "see" rather than "look." Capturing a model's attitude takes concentration. Study your model, looking for unique variations. Always approach a model as if you've never seen a person before.

Read Up on Drawing

My favorite book on drawing is Keys to Drawing *by Bert Dodson (North Light Books). Bert's book is a complete guide to drawing and doesn't suggest quick fixes. "Right side of the brain" books are helpful in understanding abstract thinking but aren't as good at helping students draw and paint a live model.*

Drawing and Painting Delicate Features

Sarah is very different from *Pierro*. He was easy to paint. Men are always easier to paint because you can be obvious without worrying about depicting delicacy or beauty—things you consider when painting young women.

Sarah's profile needs exact shapes to capture her pensive eye, the delicate shape of her nose and curve of her mouth. Painting a young person is the same as painting a carefully formed flower. Never sketch; make single line drawings until you get the shapes right. Make sure that you have an apparent light with shadow shapes as your anchor. Avoid painting a face in flat lighting without any apparent shadow shapes. It's very hard not to overwork subtle color and value variations.

Sketch of Sarah

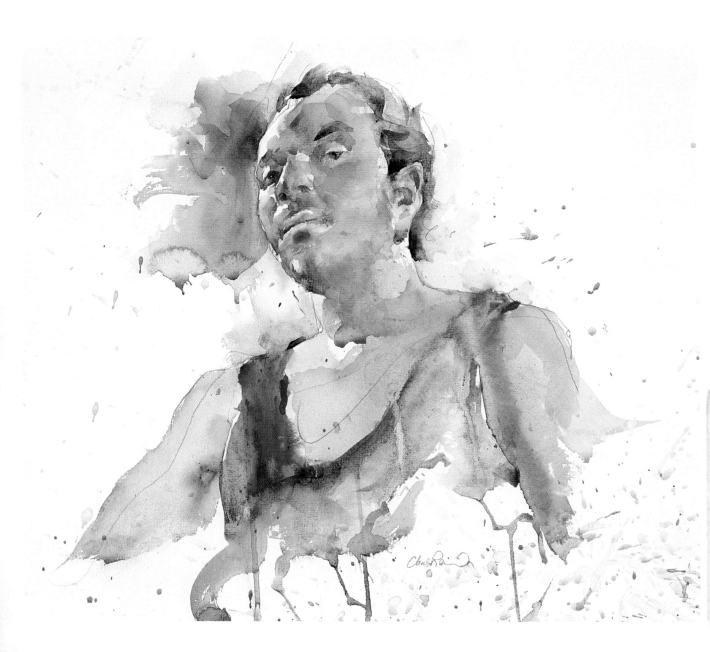

Capturing the Essence

Look for the difference between the right and left eyes and eyebrows; often one side of the face will be passive while the other will have more angles. Notice the arched eyebrow, hooded eye and curve of the mouth. All of the right-side feature shapes are different from the left-side feature shapes. Always capture the shoulder line—the thrusting up of the left shoulder adds to Pierro's attitude.

Pierro

Light and Shade Form Faces

Make sure your subjects have obvious light and shade on their faces. Work small, about 9" x 12" (23cm x 30cm). Try to see the shapes of the shadows before trying to paint your idea of an eye, nose or mouth. Always include the upper lip as part of your shadow shape and concentrate on the shape and edges of the shadow where it meets the light. Keep your shadows simple; never paint a second shadow within the main shadow. Details in shadow should never be more than one-half value darker or lighter than the main shadow.

Setting Up the Figure

Figure painting is a frustrating experience if you don't see and draw well. You must be able to catch that certain gesture, the tilt of the head and the shoulder line in relation to the face that describes your model's attitude and personality. Never draw from your conception of the model. An inexperienced student can look at a model's head that's turned away but then draw the model in the front view.

Work inside under controlled conditions until you become comfortable with your figure painting. Light is critical. Make sure you have a single light source that gives you obvious shadow and cast shadow shapes on the model's face. The trick is to see and paint the shadow and light shapes rather than the features.

Place your model in a comfortable chair. Try for twenty-minute poses with five minute breaks. You should plan for a two-hour session. Any longer and you'll find yourself losing your concentration and the model getting weary.

Working With The Model Outdoors

Working outside is a completely different experience, with changing and often diffused light. (You can't place your model in direct sunlight without a hat.) You have to work much more quickly, assuming you have sun or partly cloudy conditions. Avoid having the sun on your paper—it's hard on the eyes and makes judging color and tonal-values difficult. I always wear a visor cap and have a painting umbrella handy.

Don't Overdevelop the Face

Mary has a lovely expressive face—this can be a problem because there's always the worry that I'll get too involved with features rather than shadow shapes. I concentrated on the shadows around the eyes (making sure I got the light on the upper right lid), on the shadow in the underplane of the nose and the shape of the mouth out in the light. I "lost" the mouth as it went into shadow. Always concentrate your shadows in the features, rather than focusing on the shadows in the cheeks or under the chin, when painting women or children. Research the portrait work of John Singer Sargent and Edouard Manet.

Mary at Stow

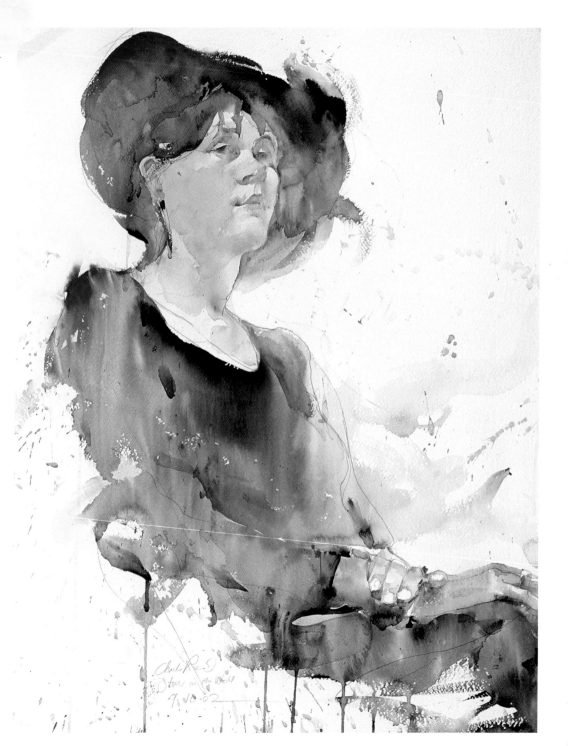

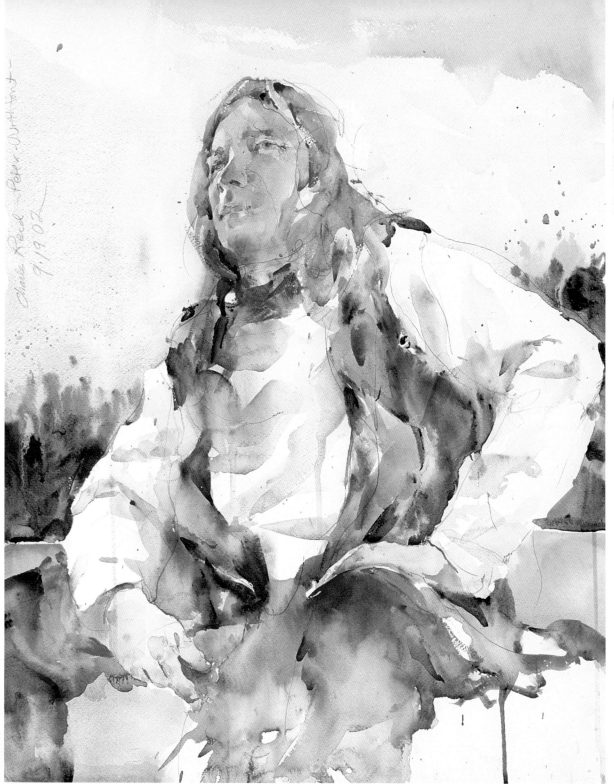

Keep Your Whites

I wanted to keep the white shirt white so I drew in the folds first and made sure the folds stayed light and luminous but had relatively hard edges by using Raw Sienna and Cerulean Blue in the folds.

Working With Your Model

I placed Peter on a table edge and let him choose this pose, which I liked but realized it would be difficult to hold. I decided on five-minute poses and planned for a one-hour session. The sun on Peter's face was great but too hard on his eyes, so I set up an umbrella for shade. This meant I had difficult diffused lighting with no apparent shadow shapes. I saw a suggestion of rim lighting on the left forehead down the side and below the nose. I left these the white of the paper and I always start my darks next to my lights.

Notice that my tonal-values are darker where they meet the rim lighting. Peter objected to his red nose, but using the red helps the nose project. Avoid restating the whole darker section of the face; just do small bits where your darker tones meet your lights. Make sure that a previous wash is completely dry before overpainting.

Peter at Urchfont

Painting With a Group

Sometimes it's hard to find time to paint. It's easier if you can arrange a regular, once-a-week session with friends, setting a scheduled painting time. Each week, have a different member of your group pose as the model. Keep twenty-minute poses as easy and relaxed for the model as possible. Have a strong, single light mounted on a stand with a reflector and light strength that suits you. Have someone monitor the lighting, making sure it is the same after each break.

Have wet paint, water and brushes ready when you finish your drawing. I'm as interested in painting the other painters as I am the model. Sometimes there's a large group and you can't get a good spot. Being close to the model is important because you must be able to see the specific shapes.

Backgrounds

Don't worry too much about backgrounds. Crowd your subject into your picture space and consider leaving your background the white of the paper, making sure to fade your figure into the white paper.

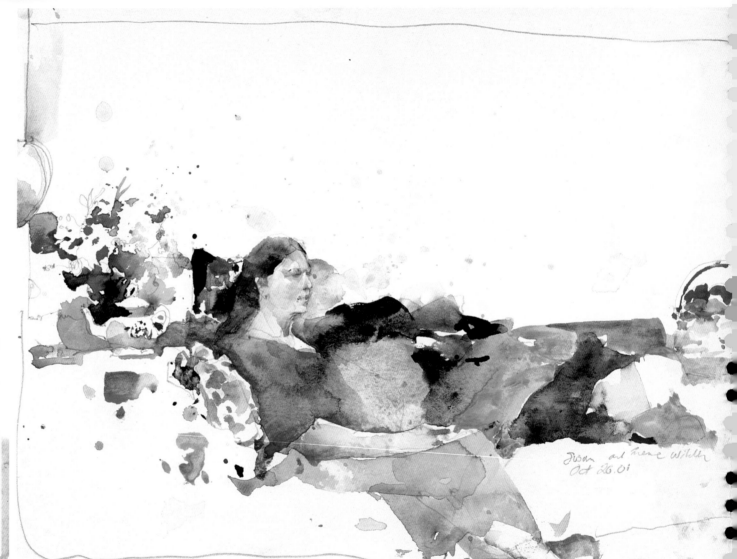

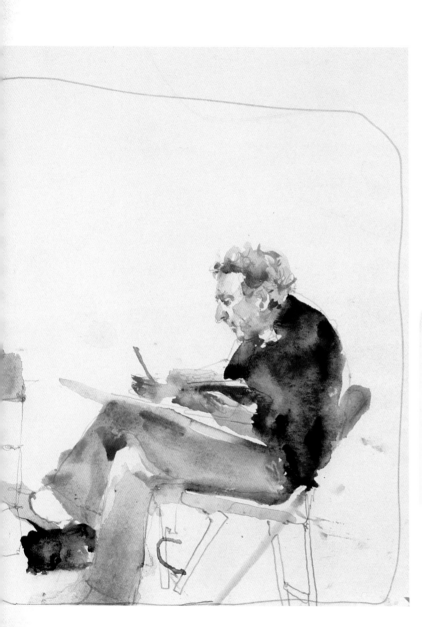

Painting With Gene Wilder and Friends

If possible, I like to have a foreground figure or object in my pictures, which provides an opportunity for careful detail and interest. You can improve any landscape or uninspiring model by simply adding a well-painted foreground subject.

This painting was done in two sessions. I waited for Gene to settle and start to draw. Gene is a dear friend whom I was more interested in painting than the models. Don't feel you must paint the model—your group members may make the best models.

Get in the habit of drawing your subject and immediately painting a "finish" of each person or section before moving on. Never try to draw several people first with a plan to paint them later. They may disappear or be in a different pose. I try to limit myself to twenty minutes of contour drawing time for the first pose.

Susan and Gene Wilder

Be Comfortable While Painting

Always be as close to your model as possible. Don't insist on standing while painting as you may do in your studio. I do almost all of my sketchbook work while sitting and I always sit when painting a model. I want to see every feature and shadow shape as precisely as possible. If you must stand in a class with many others, you'll probably need to be behind those willing to sit.

Don't feel you must paint the model—your group members may make the best models.

❄

Painting Complexions

All complexions need a red, a yellow and a complement of blue or green. When selecting the colors I use for people, I don't rely on a recipe—I mix and match. Generally, the darker the complexion, the darker the members of red, yellow, blue or green color families must be on your palette.

Here are my colors listed from light to dark. My red colors are Cadmium Red (Winsor & Newton) or Cadmium Red Light, Burnt Sienna, Burnt Umber, and Carmine or Alizarin Crimson. The yellow colors are Cadmium Yellow Light, Yellow Ochre, Raw Sienna and Raw Umber. My blues are Cerulean Blue, Cobalt Blue and Ultramarine Blue. My greens are Hooker's Green and Viridian.

For darker complexions I tend to use Cadmium Red and Burnt Sienna for my reds, Raw Sienna and Raw Umber for my yellows and Cobalt and Ultramarine Blues for my blue complement. You probably don't need a green, but see what the complexion suggests. The main thing is to keep your dark values using plenty of wet, dark pigment and just enough water to keep your mix fluid.

Never begin painting with your lights, layering colors toward your darks. Always paint your darks first when painting dark complexions, reserving the highlights.

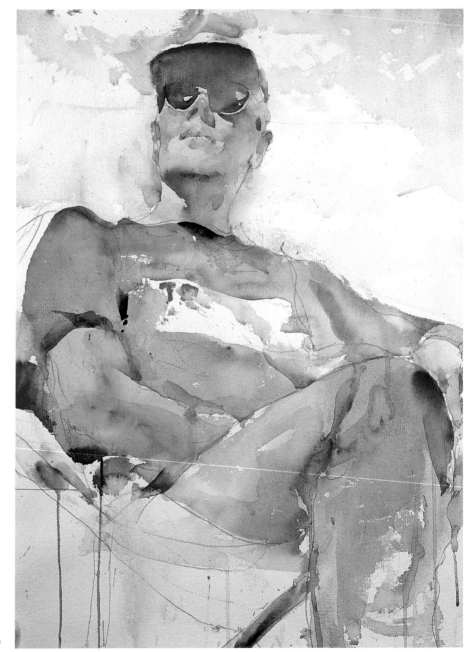

Generally, mid values are not as apparent in darker complexions, and light and shadow divisions are abrupt. Keep color and value in the lights. Don't let the complexion become washed out—the overall sense of a dark complexion is more important than light and shade.

Measuring

You'll never believe how foreshortening affects proportions until you measure. Keep a stiff arm, align the top of your pencil with the top of the model's head and place your thumbnail on the pencil aligned with the bottom of the model's chin. Keep your fingernail in place and compare the head measurement with the width of the hands and feet.

Focus on Foreshortening

If the model is on a model stand, perhaps sitting in a chair, you must deal with foreshortening. If you're painting a person at eye level, the head, hands and feet will be normal. Even then, many students make heads too big and hands and feet too small. Sitting well below the model's head means that the model's hands, knees and feet will be wider and larger in relation to the head.

Michael

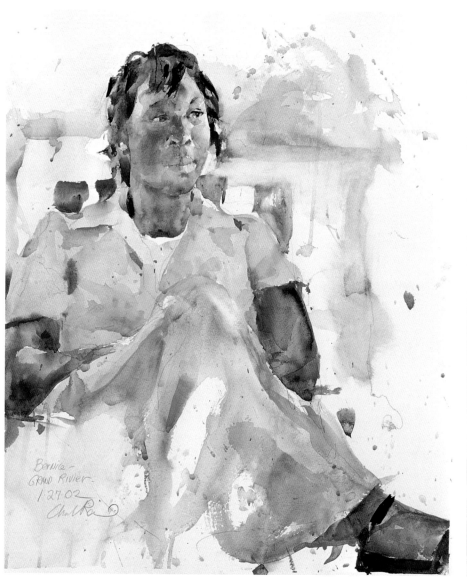

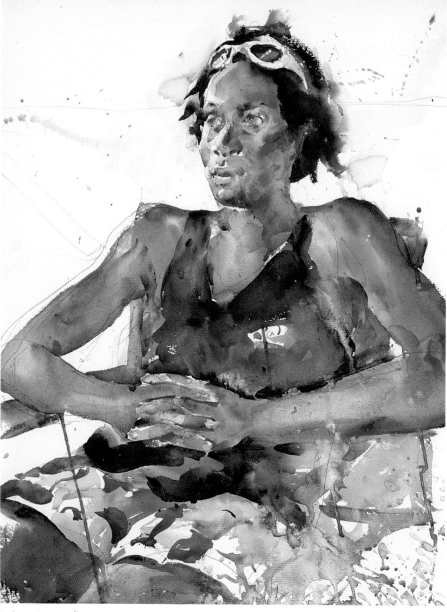

Spend as Much Time Looking as You Do Painting

Bernice is thoughtful and amused—perhaps by people she served at lunch or by being the subject of such attention while being painted by this guy who keeps squinting at her. Draw an eye, nose and mouth as if you'd never seen a person before. Compare the shapes on the right side of the face with those on the left side—they are always different. Don't try to draw quickly or with general, all-purpose shapes. I spend half my time trying to see exact shapes and tonal-value, the other half drawing and painting.

Bernice

Paint a Personality

Nigel is essentially cool—never paint a person, always paint a personality. Nigel's confidence has a male bravura while Bernice's confidence seems to have more nuances. Painting men is easier and more obvious for me. Is this a gender thing? Trying to make a woman look attractive and not caring how I painted the man? Objectively, Nigel's facial planes were more obvious. Still, I wanted to catch his fineness of features.

Nigel

The Figure

Doyle is one of my favorite models. He has a great face with color and character, and his buccaneer outfit is perfect for this demonstration—strong dark and light tonal contrasts in the clothing and apparent shadows and cast shadows on his face. If you're new to painting figures, this is the type of model you should have—rather than a lovely woman who you'll try to paint as a lovely woman. Review the painting steps in my painting of Doyle. The photographs for this demonstration were taken as I was painting, and the color and values are just as I painted them before drying. All colors and tones, even slightly diluted with water, will dry muted in color and lighter in tone.

The drawing sets the character of the painting—if it's sketchy, you'll paint a sketchy painting. If your drawing is too finished and too pleasing, you might be afraid of ruining it.

MATERIALS

Pencil
Mechanical or repelling pencils (.07mm and .09mm HB)

Brushes
Nos. 2, 4, 6 and 8 sables

Paints
Burnt Sienna • Burnt Umber • Cadmium Red • Cadmium Red Light • Cadmium Yellow Orange • Carmine • Cerulean Blue • Cobalt Blue • Hooker's or Olive Green • Ivory Black • Mineral Violet • Raw Sienna • Raw Umber • Ultramarine Blue • Violet

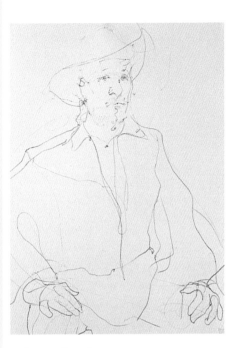

1 Draw the Subject
Drawings should never be sketchy. They should be careful in the features and hands but free in the clothing, unless your model wears a pattern; then you must be more careful. Your drawing is a plan for placing features and figure boundaries, and it's also a time to think about how you'll paint your picture. Each painting is different. You need a careful understanding of the facial features, captured with the contour drawing and a flowing, rather than completely accurate, line in the clothing and hat and then careful attention to the hands. Perhaps drawing is like dancing. It's about timing and hearing the music. "Slow, quick, quick, slow and pause."

2 Paint the First Wash
Color shouldn't be your concern here. The most important thing is to paint over boundaries of adjacent sections of similar or darker tonal-values. Carefully avoid painting over whites or near white adjacent boundaries.

Use Cadmium Red Light, Raw Sienna and Cerulean Blue in the face and shirt; add some Carmine and Violet and an Ivory Black splotch by the head. Placing a dark near the head will help you judge future tonal-values—it's hard to judge tonal-values with only white paper as your guide.

A Simple Rule
Paint your first wash over boundaries of areas of similar or darker tonal-value. Don't paint a first wash into an area you wish to remain white.

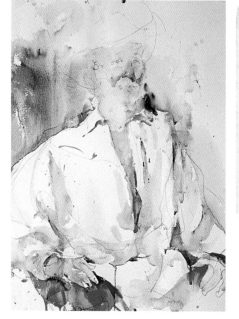

3 Add the Background and Hand

While the skin tones are still wet, paint the left background with Ultramarine Blue and Burnt Umber using a wet-in-wet mix of lots of paint and enough water to keep the colors mixing on the dry paper (you could pre-wet this area with clear water if necessary). Carefully paint the folds on the shadow side of the shirt with middle values and a touch of Carmine, Cobalt Blue and Raw Sienna mixed on the paper.

Almost finish the right hand, but leave some white paper for the lights. Try to get an idea of how much background you want and paint it in this early stage. This is the time to be free, but avoid trespassing into the white shirt out in the light. It's much harder to add a background last when you might be afraid of ruining an almost-finished painting.

4 Define the Right Side of the Painting

Add pure Cadmium Red and Cadmium Yellow Orange and a touch of either Hooker's or Olive Green and some bits of Ultramarine Blue, all mixed wet-in-wet. The fingers should be dry, but the hand near the wrist should still be damp.

5 Intensify the Color

The strong color in the face from the first wash has faded. It's very important to have good color and some middle values in the light area before adding your shadows. Almost finish the nose and cheek line before painting toward the shadow, using Cadmium Red Light and Raw Sienna. Add a touch of Cobalt Blue under the nose and in the cheek on the left. Work on the lower parts, but the addition of color out in the light is the most important.

6 Define the Face

When the face is dry, move on to this tricky step. You must have wet, thick paint for this cast shadow. Use Cadmium Red Light, Raw Umber and a touch of Cobalt or Ultramarine Blue to help darken the shadow.

Point the brush handle toward the top of the paper at about a forty-five degree angle. Use the brush tip to draw the lower contour of the shadow shape. Press the brush almost to the midpoint between the tip and ferrule and rest the side of your hand near the wrist on the paper to assure an accurately shaped shadow. Be sure not to lift the brush during your lateral stroke; it must be done in a single pass.

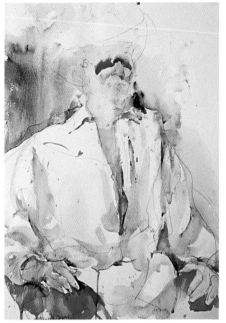

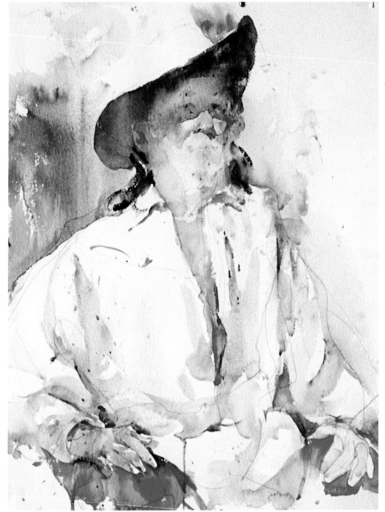

7 Paint the Underside of the Hat and Face

Don't use too much blue because you want to keep your shadows warm. If you're having trouble getting dark enough, you may be using too much water or you could try using Burnt Sienna instead of red. Paint across the face into the hat and then up and around, combining the forehead and upper hat brim, then quickly add more Cobalt Blue, wet-in-wet, to the hat on the right and on the side plane of the face on the left. You should use almost pure blue paint, and the overall shadow must still be wet.

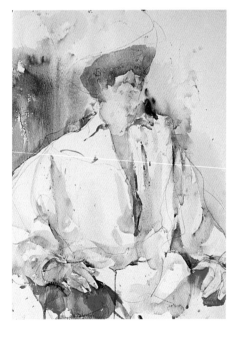

8 Paint the Hat's Shadow

While the shadow is still damp, start painting the closest part of the hat brim with Ivory Black, adding some Mineral Violet as you work to the left to make the hat brim lighter as it goes behind the head. The darkest part of any shadow or dark value will be at your starting point; you want the front part of the hat to project so that's where to start. Begin the cast shadow where it meets the light in the nose and cheek, then paint over and up causing a lighter forehead that suggests reflected light. Cast shadows are usually hard edged.

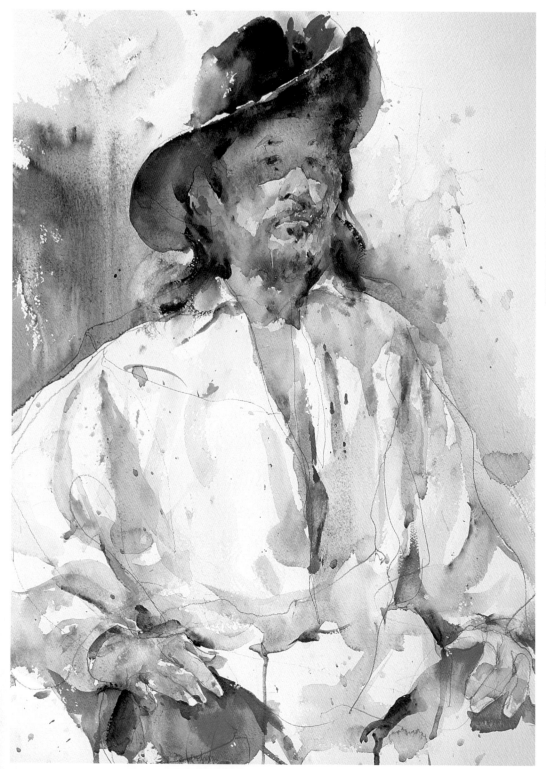

When to Finish

It's hard to know when you're finished. There's always a temptation to add a few more darks—usually a big mistake. I wish I hadn't added more darks (or hadn't made them so dark) around the face, hair and hat. The crown of the hat is also a bit too dark and wants to come forward. Compare the finish with Step 8 and see if you agree.

Finish

If the eyes are in the shadow, always paint them after you paint the shadow. The moustache and goatee are a combination of first wet-in-wet, then a little dry brush.

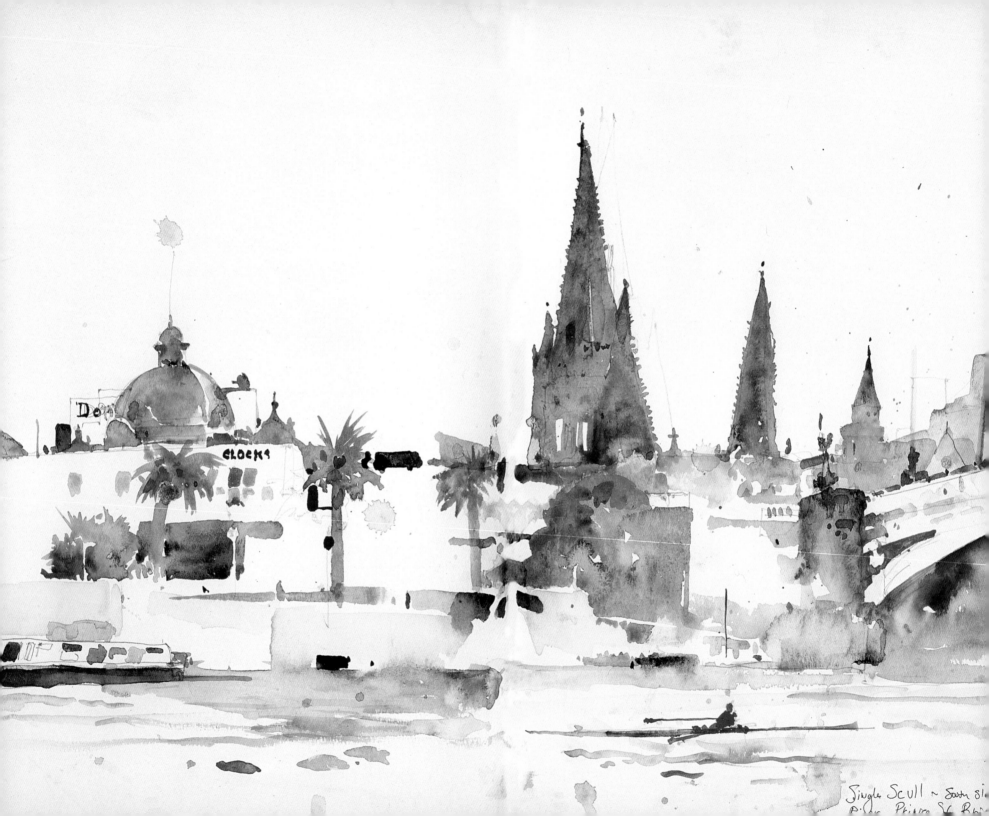

Single Scull ~ South Si...
...Pigeco ...

3 | Travels Near and Far

It surprises me that so few of my students are prepared to paint outside. Most of the paintings in this section were done on my lap in a folding chair, using a small handheld palette with an attached water container, nos. 2, 4 and 6 round sable brushes, a water bottle and my sketchbook. You need a small, contained kit that you can carry easily and that will survive sun and shower. Unfortunately, I think an umbrella is also necessary. Chair and umbrella kits are available from Art Xpress and other fine art suppliers. An easel isn't necessary but can be used if you wish. Once when I was painting in Rome, I was suddenly pelted by a heavy rain shower and huddled under my umbrella until it passed.

I don't use photographs for reference because I have trouble painting from them; capturing the immediacy of the moment in my sketchbooks works best for me. A camera may be good for future paintings, but sketchbook paintings seem more satisfying than a slide show or photos in an album.

Snapshot Painting

John Singer Sargent thought of his wonderful outside watercolors as snapshots. He apparently didn't spend a lot of time finding a picturesque scene but would sit down and paint whatever was in front of him. Don't wander around hoping to find a wonderful scene; find beauty in your first ten minutes of looking. So many wonderful paintings have been done from the most common of subjects.

Find the essential elements that attract you to a scene. First ask yourself: What interests me? You can't paint everything, so decide what is beautiful and make what is beautiful dominate your page. Paint your first impression and stop. Never correct or rework a painting done on the spot. Make a new painting using your snapshot as a reference.

Single Scull, Melbourne, Australia

A Mid-Valued Painting

I painted the dark, distant hills on the upper right first; never try to paint a light or mid-value painting without painting a dark to compare your values to. After establishing my dark, I then concentrated on the sheep and cast shadow shapes beneath them, followed by the carefully painted the trees. This painting has simple, broad areas with some very articulated detail. This is a good goal for you to strive for.

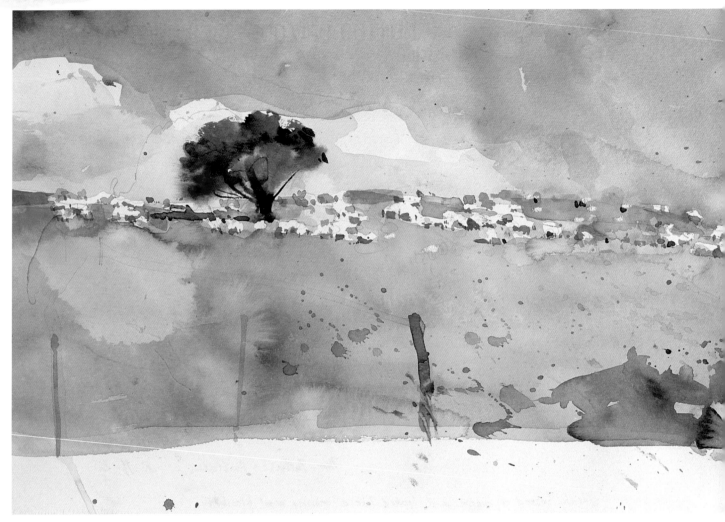

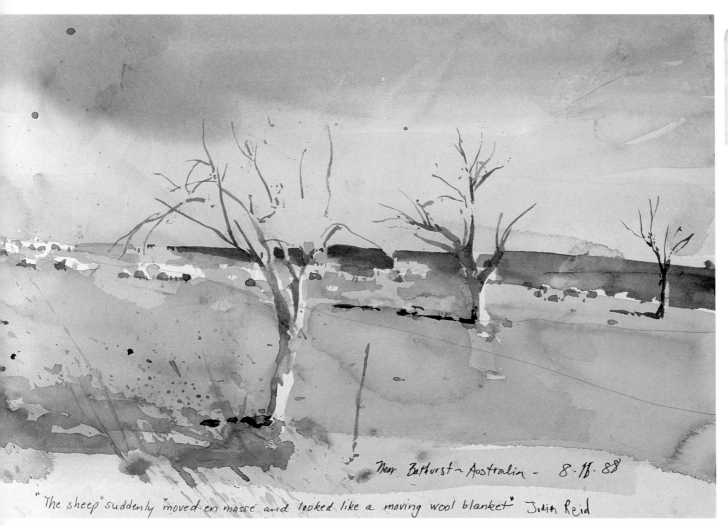

Near Bathurst ~ Australia ~ 8.11.88

"The sheep suddenly moved en masse and looked like a moving wool blanket" Judith Reid

Using Distinct Tonal-Values

I was attracted to the white sheep with their dark cast shadows, the low white clouds and lonely mid-dark cottonwood trees set against a mid-light field and sky. I identified and kept the identity of each tonal-value area. The trick is to keep squinting and don't fudge! Stay true to the scene in front of you and record what your eyes see.

Near Bathurst, Australia

51

Using Both Pages of a Sketchbook

I like to work across both pages of my sketchbook. Sometimes I run out of things I want to paint, so rather than doing something foolish, I stop, thinking that later I might add a vignette that relates to my visit. I painted this poolside scene while staying at the Hotel Antigua in Guatemala. I added the parrots a few days later using the same palette. Vignettes can add a new dimension to your sketchbook. They are an opportunity to focus in on a small detail, an important feature or any element of your painting that you want to explore in depth.

Let White Paper Lead Your Eye
I like to use white paper when I don't know what else to do or I have very light tonal-values. Keep your white paper untouched if you are not sure of your tonal-values or if you cannot decide what to do next—you can never get it back but you can always add a tone later. White paper is also a great way of leading the eye through the painting. I have a parrot on the left, so I added a study of parrots a few days later in my empty space.

Hotel Antigua, Guatemala

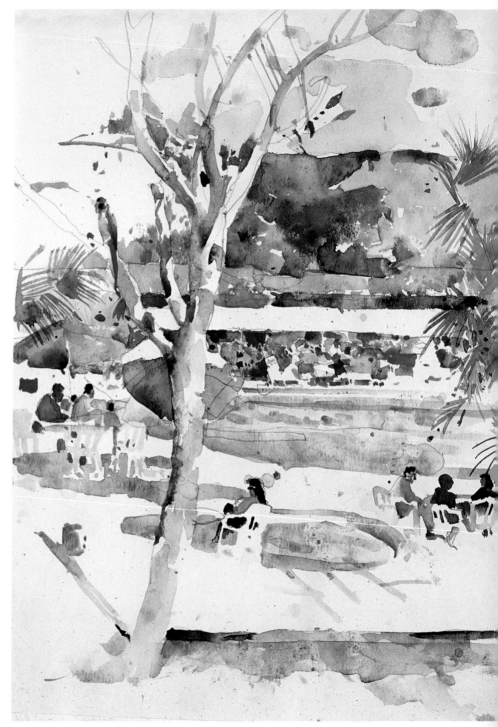

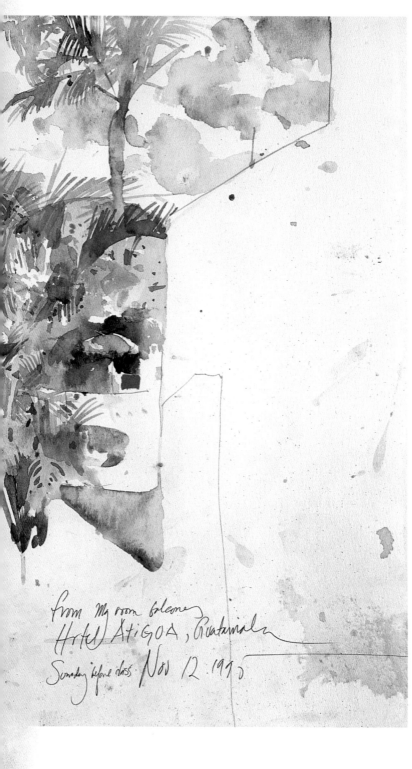

from My room balcone
Hotel ATiGOA, Guatemala
Someday before class· Nov 12·1970

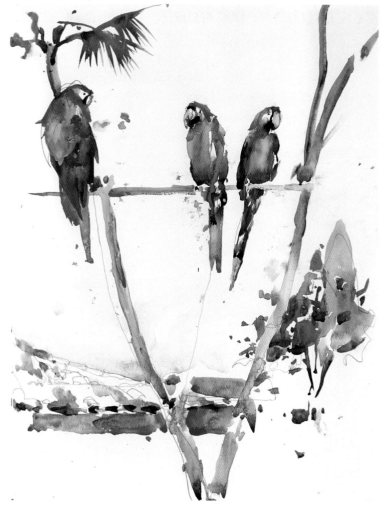

Adding Vignettes Later
I painted the parrots' middle and darker colors with pure, moist paint mixed on the paper a few days after I completed the scene from the hotel in Antigua. I saved my whites and the parrots' beaks with hard edges. After the surrounding darks dried a bit, I softened and added lighter tones.

Parrots, Hotel Antigua

Vignettes can add a new dimension to your sketchbook; they provide an opportunity to focus in on a small detail.

❋

Using the Magic Triangle in Your Compositions

When selecting your subject matter, find two or three elements that you really want to paint. Draw and paint these elements as carefully and as well as possible, then omit or simplify the other bothersome stuff. I often use the classic and simple principle of the magic triangle. Remember, this principle groups three elements so they form a triangle on the paper. Usually two of the elements will be relatively close while the third point of the triangle will be more distant. This grouping creates interest and a tension on the picture plane. If you don't have three subjects you want to focus on, a dark tonal-value or intense color can be used in place of a person or object.

Grecian Travels

Greece is a painter's dream because it lacks difficult subtle midtones. Greece is gloriously obvious with a Peacock Blue sea, whitewashed buildings and a Cerulean and Cobalt Blue sky.

I packed a bottle of olive oil in my bag for the trip back to Athens from Santorini. As the bag came around the carousel, I saw it trailing a suspicious path of liquid. Avoiding honest disclosure of our airplane's oil-tainted baggage, I snatched my bag and ran to the restroom for a quick fix. When I peeked around the restroom door, the baggage room was empty except for the single figure of my wife, Judith, gazing at me skeptically.

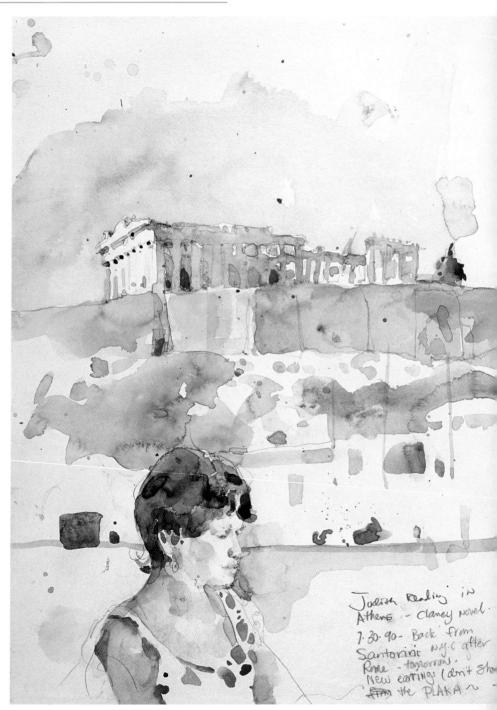

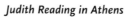

Color Can Be Your Subject Matter

You can use abstract color shapes instead of objects to accent and create interest in your painting and avoid unwanted clutter. Keep your paintings interesting and simple—don't fill the page with unwanted or extraneous items. Less is more.

Judith Reading in Athens

e other side

55

Using Detail in Some Places, Omitting Detail in the Rest

The trick to painting any very complicated subject is drawing and painting some parts with explicit detail while leaving some parts simpler with less detail. The more detailed parts should have harder edges and more tonal-value contrast. (Don't confuse this with developing a center of interest.) The areas of explicit detail should be located in three or four places throughout the painting.

Other parts of the painting should have lost edges and less tonal-value contrast. The goal is to have both explicit detail and generalization in your painting. This creates variation, which in turn creates interest and holds the viewer's attention.

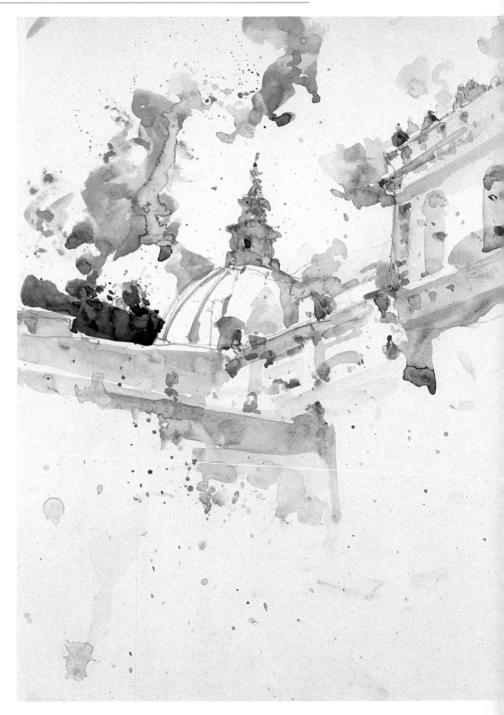

Painting South of the Border
I've made three trips to Guatemala. It's a troubled country but filled with color and a beautiful and proud people. I suggest taking a Polaroid camera and having the picture handy in payment for each important person in your photograph or painting when in Mexico and Central America. They assume that you are going home to make lots of money from their images. I usually stand with my back to a wall to avoid kids and remain oblivious to passersby.

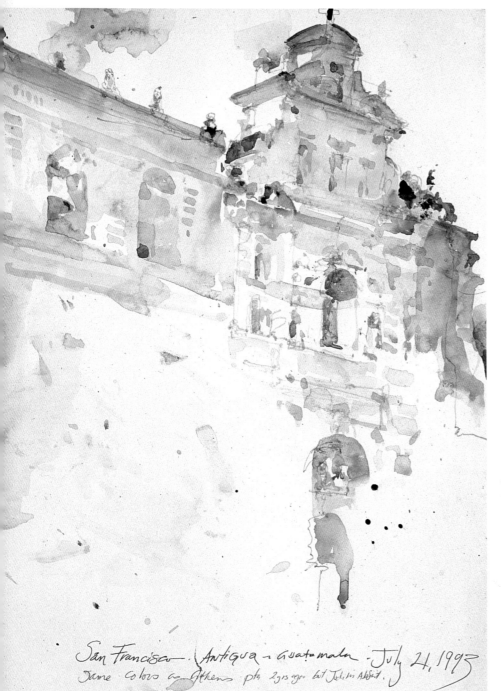

San Francisco · Antigua · Guatemala · July 21, 1993
Same colors as Athens pts 2 yrs ago but Julitin Absent.

Strive to have both explicit detail and generalization in your painting.

❇

Design Your Paintings

Always design your page using your areas of explicit detail. This painting has the Baroque facade in the upper right and the dome on the left to guide the eye to the parts of the painting that are of interest. Along with the explicit detail, I use mid-dark shapes and sometimes a spot of color (notice the lower right doorway) to keep the viewer's eye moving throughout this painting of the Cathedral San Francisco in Antigua, Guatemala.

San Francisco, Antigua, Guatemala

Putting Interesting Figures In Your Painting

Avoid painting generalized, canned figures in your paintings; instead, paint real people. It's easiest if you can paint your figures with the main light behind them so that you can see and paint carefully shaped, darker silhouettes. Try skipping the pencil drawing and go for the paint right away. Have your palette, water and nos. 3 and 4 round brushes handy. Don't think of painting people, think shapes and values! If you think about your subject as a person, your pre-conceived ideas of what people look like may prevent you from painting realistically. Squint and concentrate on accurate, interlocking darker shapes—that is all you need for success.

Place People First

People weren't really necessary for this painting, but it makes a better composition to add something in the foreground. I always add the people first if they're there. I made three of my figures dark shapes to tie in with the cathedral's darker shapes. The man wearing the T-shirt ties into my light background wall.

I started with my figures, letting them set the scale of my painting. I didn't make a preliminary sketch or plan the proportions of the cathedral. Start with a well-painted figure. Use it as your foundation and relate all else to it.

Ciudad Viejo

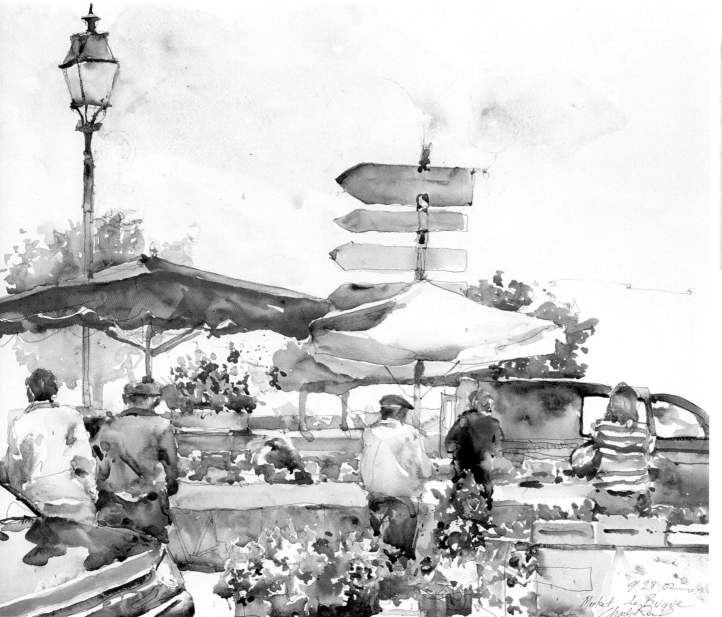

9.28.02

Market Le Bugue
Charles Re...

Painting Unsuspecting Subjects

First, you must find a figure who seems to have companions in conversation. I watch my victim until I'm pretty sure he'll stay. I start my drawing with my mechanical pencil anchored to the paper. When the model moves, I stop, keeping my pencil motionless on the paper until he returns to the same pose. I paint my figure immediately, along with the adjoining shapes. Don't attempt to sketch the whole scene or worry about your composition. You can correct or add any other elements to balance the scene later.

Putting a Painting Together

This picture took about two hours. The figures were done in ten minutes or less. Most of my time is spent seeing and waiting for a subject who will stay still. Between figures, I finished the car and painted the dark side of the table, flowers, awnings, lamp and signs. It's like putting a puzzle together. Always look for darker (negative) background shapes that will bring your lighter foreground shapes into focus.

Le Bugue Market

Quickly Capturing the Location You Are Painting

I like white paper. If I'm not committed to an area or if I think an area in my subject will take away from my painting idea, I'd rather leave it untouched. Sketchbook work, for me, is to find the essential elements that capture the place I'm painting. Only select the detail that is needed. Work quickly—less is more.

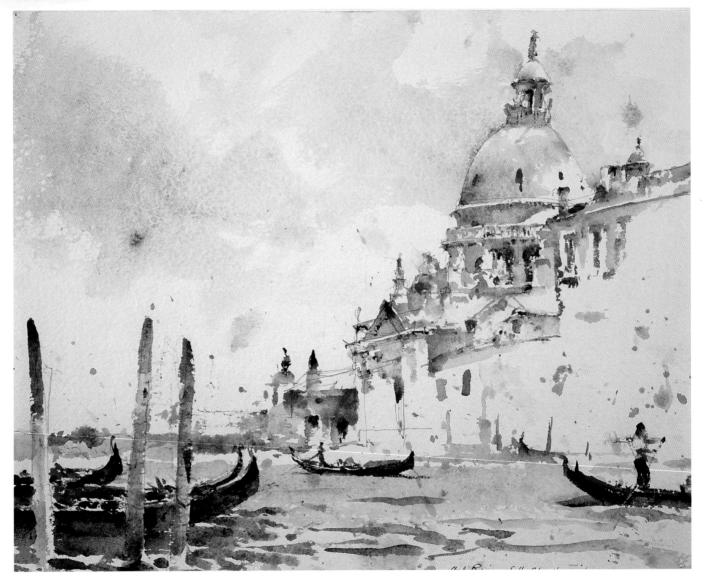

Make Every Stroke Count
I thought of my lack of time while sitting on a narrow pier, sketchbook in my lap, with John and Malcolm on the Grand Canal in Venice, Italy, busy with water taxis and arriving guests. You can't think of doing first washes and layering paint at a time like this—every stroke has to be a finished stroke with the right tonal-value and color. As I worked, I corrected for tonal-value and color, working wet-in-wet, striving for a finish in the palace before going on to the docked gondolas and their reflections. I painted the water and passing gondolas last. I added some more ripples when the water was dry.

Venice, the Grand Canal

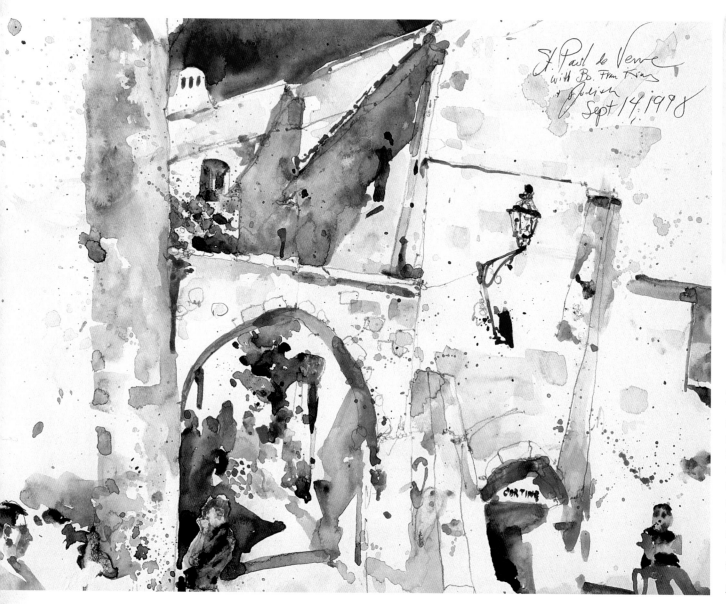

St. Paul de Vence
with Bo, Fran Kias
+ Julian
Sept 14, 1998

CORTINE

Compare Values

Painting the walls of an ancient town in France is tricky. They aren't white but often a dull gray or tan. You should never attempt to paint the wall's texture or start with a light, dull gray wash. Squint and compare. Compare the wall with the tonal-value of the sky and any cast shadows. Unfortunately, you need a sunny day to see these relationships. Painting a scene like this would be very difficult in flat lighting. I always start with my darks and mid-darks and save my white paper until last so I can properly judge the relative tonal-value of my lighter tones in relation to my darks.

Abstraction Captures Reality

This painting is basically an abstraction based on an intense cobalt sky and the mid-dark and dark shadow shapes. I used Cobalt Blue, Cadmium Orange, Raw Sienna and Ultramarine Violet in the foreground cast shadows. I painted a strip of the left wall out in the light. After I'd done my shadows, I decided if I painted the remaining light-struck walls with similar tones, I'd lose the sense of sunlight. Be conservative with your paint and let the white of the paper work with your tonal-values.

St. Paul de Vence

Using a Full Palette

Try to limit your color selection to sixteen pigments at most. Find the colors you use on a regular basis; I bet you'd be surprised how many you have on your palette that you don't use.

It's really about overmixing. Don't overmix; instead, use colors directly from your paint supply rather than the homogenized paint from your mixing area. If you follow this practice, you'll have wonderful color variety. It is OK to mix a bit in the mixing area, but you should always be able to see bits of all the colors you're using.

My Basic Palette

My basic palette is Carmine (Holbein), Cadmium Red (Winsor & Newton), Cadmium Red Light (Holbein), Cadmium Yellow Light, Cadmium Yellow Pale, Yellow Ochre or Raw Sienna (they are almost identical; I use Yellow Ochre when painting people, it's slightly lighter. If I had to choose one, I'd pick Raw Sienna), Cadmium Orange, Burnt Sienna, Burnt Umber, Olive Green, Cerulean Blue, Cobalt Blue, Ultramarine Blue, Ultramarine Violet and Ivory Black. You always need a Carmine or Alizarin Crimson, and have some choices when purchasing paints. Try the permanent versions from Holbein or Winsor & Newton if permanency is a consideration for you. I've used Holbein's Carmine for years and have never had fading problems. You should decide if you prefer Hooker's Green, Oxide of Chromium or Viridian for your greens; you don't need all three. I also use mixed greens with Cadmium Yellow or Raw Sienna or Ivory Black and a yellow or Raw Sienna.

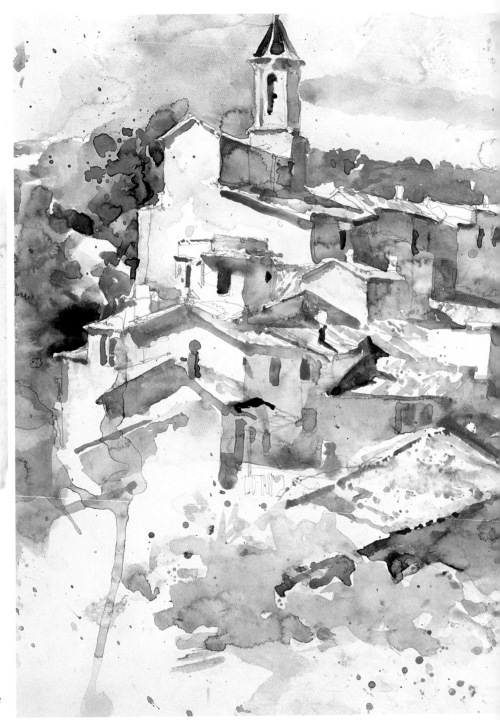

Applying Paint

I used Cadmium Red, Cadmium Orange, Cerulean Blue and Cobalt Blue in the buildings and Carmine in the darks in the roofs. I used Olive Green, Raw Sienna and Ultramarine, Cerulean and Cobalt Blues to finish the painting. Some Ultramarine Violet was used in the green hills on the left. Most of my paint mixing is done on the paper rather than pre-mixing on the palette.

Peillon, France

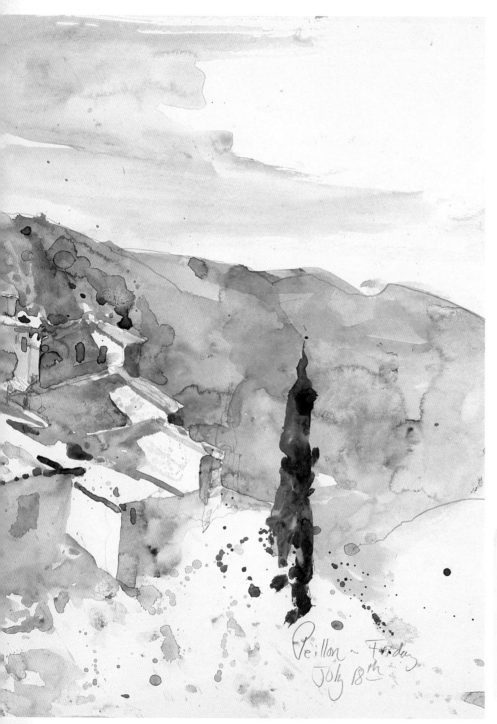

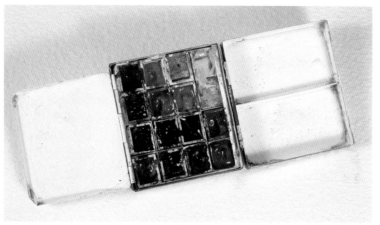

My Travel Palette

I favor Holbein watercolors, which don't crumble with disuse and are easily brought to life with a squirt bottle. I use a sixteen-well color box, made by The Paint Box Company in the United Kingdom. It's expensive, about the cost of a very good tennis racquet. I have favorite colors I always use, but I still try new ones. My color selection is not set in stone; I often experiment with new colors.

Here's my current palette. All of these colors are considered permanent. (Holbein uses three stars and Winsor & Newton uses an "AA" or "A" for their permanent colors. Two stars or "B" means relatively permanent. I've often used Mineral Violet, Hooker's Green, Alizarin Crimson and other colors rated as "relatively permanent"; give them some consideration.

Top row, left to right: Carmine, Cadmium Red Light, Cadmium Yellow Orange, Cadmium Yellow Light.

Second row, left to right: Burnt Sienna and Burnt Umber (set side by side in one well), Raw Umber, Raw Sienna, Cadmium Yellow Pale.

Third row, left to right: Ivory Black, Bamboo Green, Viridian, Cerulean Blue.

Fourth row, left to right: Mineral Violet, Peacock Blue, Ultramarine Blue, Cobalt Blue.

My Travel Palette

I have a limited palette that I use when traveling. I have a small box with just six colors; I have taken this palette on many trips and have painted little pictures that suggested many colors. My travel palette consists of Alizarin Crimson, Cadmium Red, Cadmium Yellow Pale, Raw Sienna, Hooker's Green and a blue, either Ultramarine or Winsor Blue. Try this limited palette and concentrate on good tonal-values. Use only the colors you need and keep your colors moist with a small, handy spray bottle.

Sunny Days Create Simplification

Simplification is a word that's always true to good painting. One key to simplifying is a sunny day that will give you simple shadow shapes. The next key is seeing and painting local tonal-color (the true tonal-value and color of the primary colors yellow, red and darker shades of blue and the secondary color orange), and all inherently dark color tonal-values (black, dark earthtones and greens). All of these as they are seen in nature should remain true as if unaffected by light.

Where Is Pure Color Used?

Can you find where pure color was used in this painting of the Hotel d'Europe? Cerulean Blue, Cobalt Blue, Raw Sienna and Raw Umber or Burnt Umber were mostly mixed directly on the paper for the building shadow shapes.

Look for shadow shapes that describe architecture. Ask questions like these: How do local tonal-color and darker negative shapes help show the figures in the lower right? Where was pure color used directly from the paint supply?

Hotel d'Europe

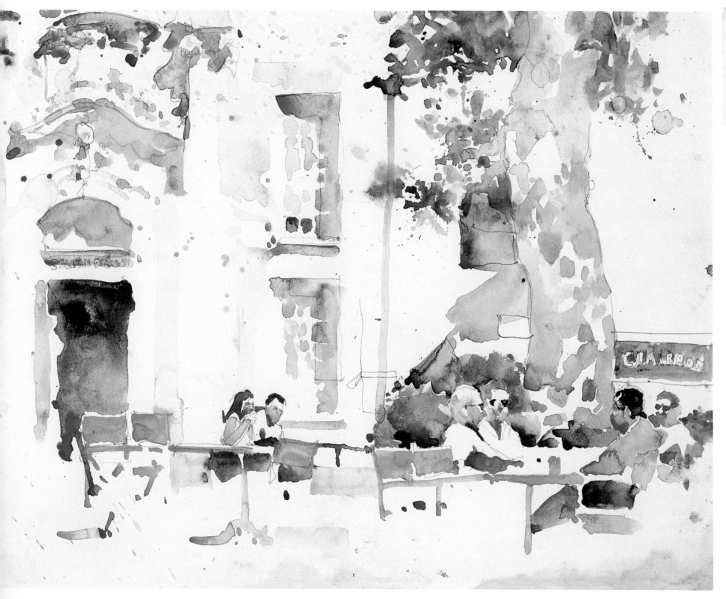

Edge Control

Soften edges while you're painting; know when to find a hard edge and when to lose it. If a boundary is easy to see when you squint, make it hard; if a boundary is hard to see when you squint, soften it.

Exercise

Painting in Strong Light

Find a subject in direct sunlight or a strong, single light source. Paint only mid to dark local tonal-values and shadows combined with the cast shadow shapes, leaving all light tonal-values white paper. If you have any primary or secondary colors, keep at least half of them as pure color without adding a complement.

Hotel d'Europe—Avignon

I'd done a poor demonstration of the famous incomplete bridge in Avignon for my morning class and felt depressed. When I do badly, I think of the basic art principles and return to them. I concentrate on shadow and cast shadow shapes and local tonal-value. Leave light tones white paper (you'll need a sunny day).

65

Painting Mountains

Mountains are normally dark and dominant forms but depending on weather, sunlight and geology every painted mountain can look unique. Carefully observed and drawn shapes are the one constant. Nature never repeats itself, so don't draw a symmetrical mountain. Keep your pencil on the paper—no lifting. Pretend your pencil is actually on the shape you're drawing rather than on the paper. At each slight directional change I stop and make a dot, then decide on a new angle and direction for my pencil to follow. Concentrate!

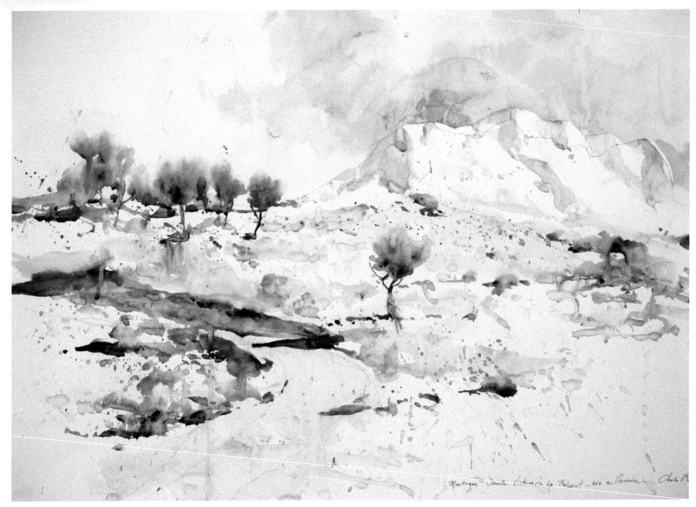

Capturing Mt. St. Victoire

Mt. St. Victoire is limestone and struck me as an amazing, white glacier shape. Paul Cézanne painted it as an off-white. He painted masterpieces of this very mountain, so it took on a mystical appearance for me. I left out lots of trees and rock detail. I wanted the whiteness of Victoire to dominate, so I let the whiteness work into the middle distance so the mountain appears larger than it really is. I used some mid-darks on the left for balance. Always keep the painting goal—capturing and accenting Mt. St. Victoire—in mind. Paint slowly and think, deliberately avoiding distracting detail.

Mt. St. Victoire

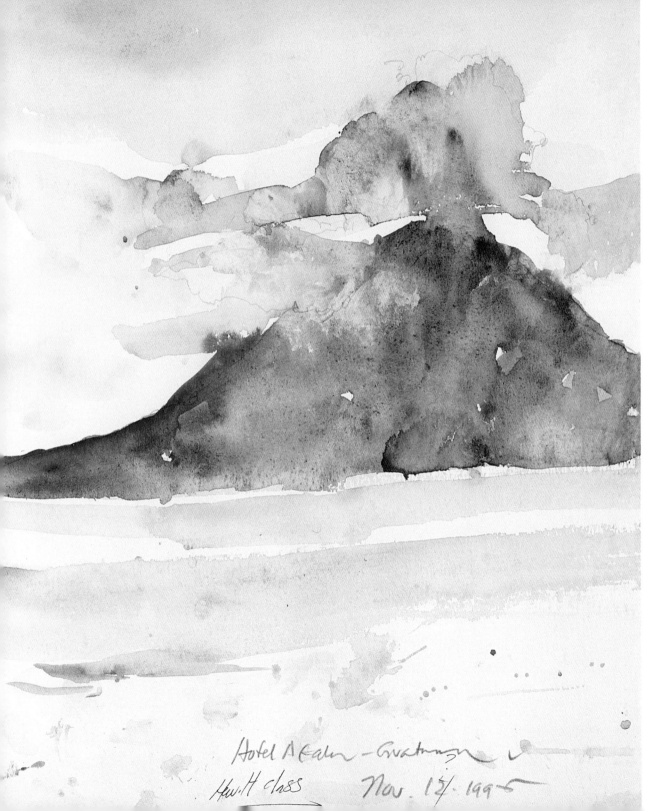

Hotel Atalan – Guatemala
Hew.H class Nov. 15, 1995

Forget Your Painting Method

The volcanic dark cloud shrouding the peaks across Lake Atalan needed a different approach than I used for the bright white limestone of Mt. St. Victoire on a hot, cloudless day. I wanted an arid clarity in Victoire; a wetter look in Atalan was helped along by passing showers hitting my paper. No matter what subject you paint, come to it without a method of painting. Paint as if you don't know how to paint. Absorb yourself in the subject and let it tell you what to do. You'll need to paint a lot to have this wonderful experience, but it's worth the time and practice.

The passing showers caused my wet look so I went with them, using lots of pigment and only one layer of washes. I let the raindrops do some of the blending, controlling them a bit with the tip of a tissue. The cloud passing before the peak on the right was dabbed lightly with tissue while the peak was still wet. Unable to do justice to the warmly tinted cumulus clouds, I used Cadmium Yellow, Cobalt Blue and Carmine, all diluted. Then I used Ivory Black, somewhat diluted, but mixed with water on the paper, for the passing shower clouds.

Lake Atalan

Mixing Colors

The less mixing you do, the richer your paint quality will be. The more you mix, the duller the color will be. I have no knowledge of the chemistry of paints—I just know that the less I mix, the better the color. One way to do less mixing, especially in your darks, is to let your colors mix directly on the paper. I like warm and cool color temperature variations throughout my paintings, so when I choose a warm or cool color for mixing I try to find a tonal-value match. Lighter, warm tonal-valued colors match with lighter tonal-valued colors. You'll have to work out these colors on your palette with just a bit of water to diffuse the opaque pigment.

Testing Your Colors

Color mixing on the paper and still keeping a basically dark tonal-value is very difficult; it takes time and lots of practice. Spend time with color swatches, working toward a warm and cool swatch that matches the overall tonal-value you want. For example, it is important to switch from light-valued yellows like Cadmium Yellow or Aureolin Yellow to darker earth yellows like Raw Sienna or Raw Umber. When using blue pigments, switch from Cerulean Blue to Cobalt Blue and then to Ultramarine Blue. Choose colors for their inherent tonal-value rather than their hues. Important: In the meantime concentrate on getting the right tonal-value with your first wash, regardless of color.

Color or Tonal-Value

I never studied color in art school; rather, my training concentrated on understanding tonal-value and drawing. Chip Chadbourn introduced me to Pierre Bonnard, and I found the simplest of color formulas—paint warm and cool everywhere and you can't go wrong. It's true that warm colors come forward and cool colors recede. I never think about this except in close-valued figure paintings. In Craig Painting, the manor had a red roof and red brick siding. You can't paint what you see—you must paint what the picture needs. Good paintings contain a variety in shape, intensity and hue, so I arbitrarily added Cobalt Blue into the roof and sections of the siding, windows and door.

Finding Your Colors

This was a dark day. The roof was an earthy dark red and the brick siding was a confusing collection of light and neutral bricks mixed with red ones. I used the "seek and find" principle when choosing the colors I was going to use. I had no plan other than keeping a mid-dark tonal-value in the roof. I thought of the roof as a color swatch mixing Burnt Sienna, Cadmium Red and Cadmium Orange with Cobalt Blue, never mixing much with my brush but letting the colors mix themselves.

Craig Painting at Urchfont

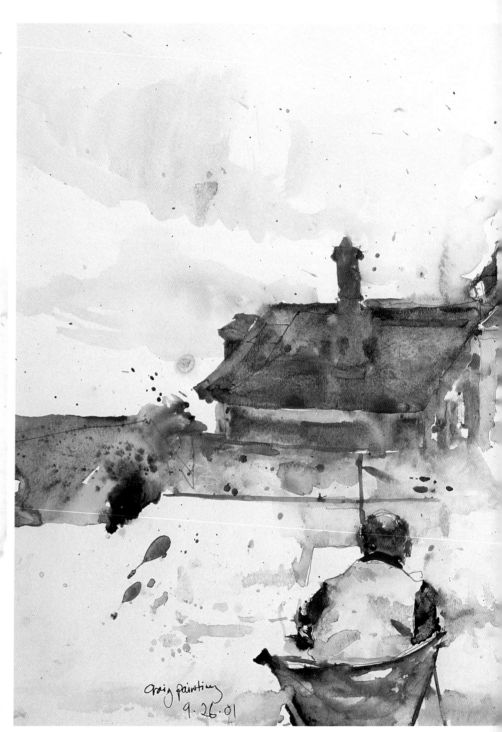

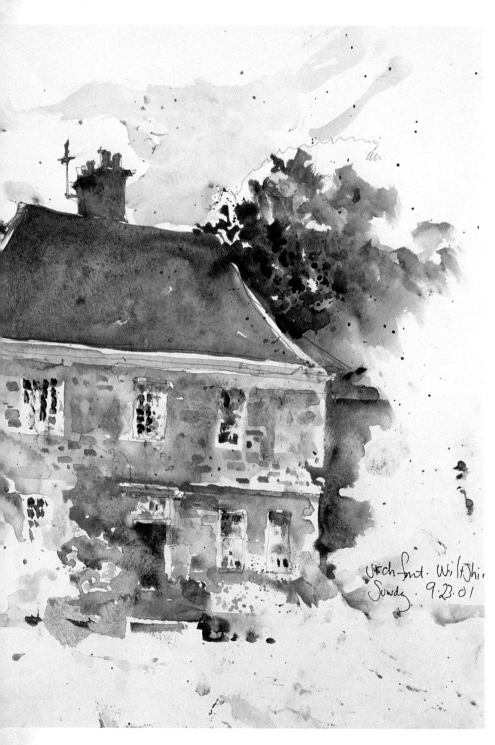

urch Ed. Wiltshire
Sunda 9.23.01

1. Basic light complexion—2/3 Cadmium Red Light, 1/3 Cadmium Yellow Light with Cerulean Blue. The blue must be worked out on the palette before adding it to the proper mix of red and yellow. The blue shouldn't be too watery.

2. Light complexion shadows—1/2 Cadmium Red Light and 1/2 Raw Sienna with Cerulean or Cobalt Blue. Mix the blue separately on the palette. Use Cobalt Blue for a darker version. Adding less water will give you a darker tonal-value.

3. Dark complexions—Burnt Sienna, Ultramarine Blue, Bamboo Green and a little Raw Umber. Some darker complexions are cooler—use Ultramarine Blue. Some are even cooler—use Hooker's or Bamboo Green. Vermilion and Cadmium Red don't fare well when diluted with water and aren't good mixers, except with green. I always use Alizarin Crimson or Carmine for my mixing reds.

4. Basic mix for dark warm and cool grays—Carmine, Cobalt or Ultramarine Blue, Raw Sienna or Yellow Ochre.

5. Light version for mixing warm and cool grays—Carmine, Cerulean or Cobalt Blue, Raw Sienna or Yellow Ochre.

6. A light fresh green—Cadmium Yellow Pale or Aureolin Yellow and Cerulean Blue.

7. A darker, more neutral green—Ivory Black, Cadmium Yellow Light, Cadmium Yellow Pale or Aureolin Yellow.

8. Earthy greens—lighter, Yellow Ochre, Cerulean or Cobalt Blue; darker, Raw Sienna or Raw Umber with Cobalt or Ultramarine Blue.

Using More Than One Center of Interest

My pictures are based on a subject I draw and paint very carefully, focusing on something I know to be true. I use this as a base and relate my colors, tonal-values and proportions until I get away from my base and find a new base—the idea is to weave adjoining shapes based on previous adjacent shapes. I want my whole painting to have centers of interest with equal interest in my foreground and background.

Painting Craig and Alice, West Dean, UK

Starting with Craig, I complete a contour drawing—the most time-efficient way to capture accurate shapes. I paint Craig immediately, his cast shadow, paint bag and easel, making sure I cross over boundaries between areas of similar tonal-values. I leave a narrow white border between areas of dissimilar value so I can keep darks from bleeding into the lights I want to preserve. Next comes Alice and the grass around both. I was as interested in the strong sunlight making contrasts of simple shapes in the distant landscape, as I was in the figures. The contrast between the trees, cast shadows and grass are probably too strong and dominate the figures, but I was overcome by a rare sunny day in southwestern England.

Craig and Alice, West Dean, UK

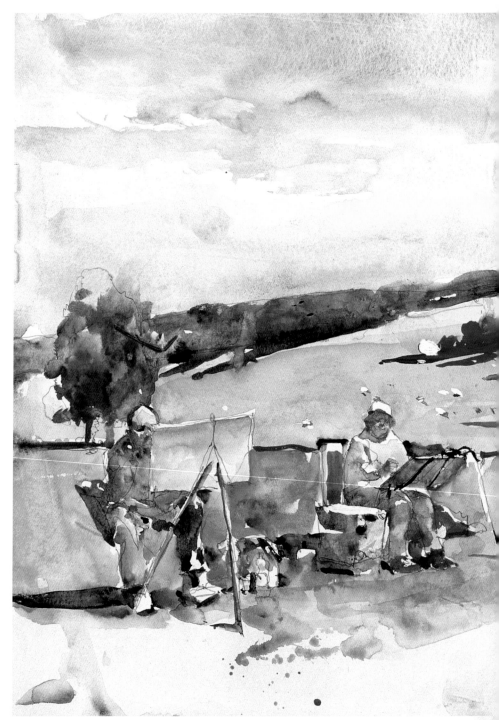

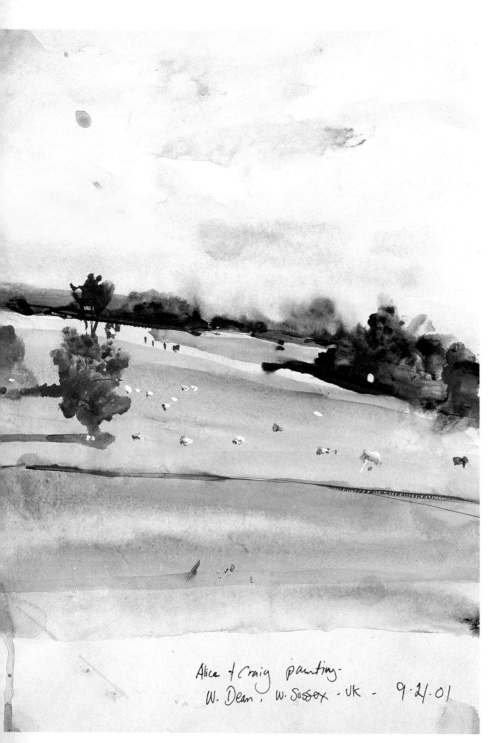

Alice & Craig painting.
W. Dean, W. Sussex - UK - 9·21·01

You can't always paint what you see—
sometimes you must paint what the
picture needs.
❋

The Center of Interest

The need for a center of interest in paintings has
always eluded me. People, animals and flowers
will automatically be a center of interest without
your help. Try to paint all areas as well as you can.
Paint lost and found edges throughout your
painting. Don't concentrate on one area (your
supposed center of interest) or you'll overwork
the painting. You'll see more value contrast in the
landscape, but your eye still goes to Craig and
Alice.

Painting Your Passion

Finding a subject you like and a room with a view is rare, especially if you find airplanes and airports fascinating, like I do. My dad flew in World War I (at age 17), barnstormed and flew the airmail and then liquor during Prohibition in the 1920s. He survived and encouraged me to become an artist and not to have anything to do with airplanes other than painting them.

Painting on Location in Issaquah

This county airport near Seattle, WA is gone now, the land turned over to development. I had a watercolor sketch box and a sketchbook with light drawing paper and a whole morning to paint. I painted the page on the right first. You'll see the tonal-values are unintentionally a bit darker on the left page. The big lesson I learned was the need for direct painting without corrections or overpainting on light paper; I've since followed this advice, even on watercolor paper. Paint and finish small increments; paint mid-darks and darks first, using wet-in-wet washes. Save white paper for your whites and deal with the mid-lights last.

Holiday Inn, Issaquah, Washington

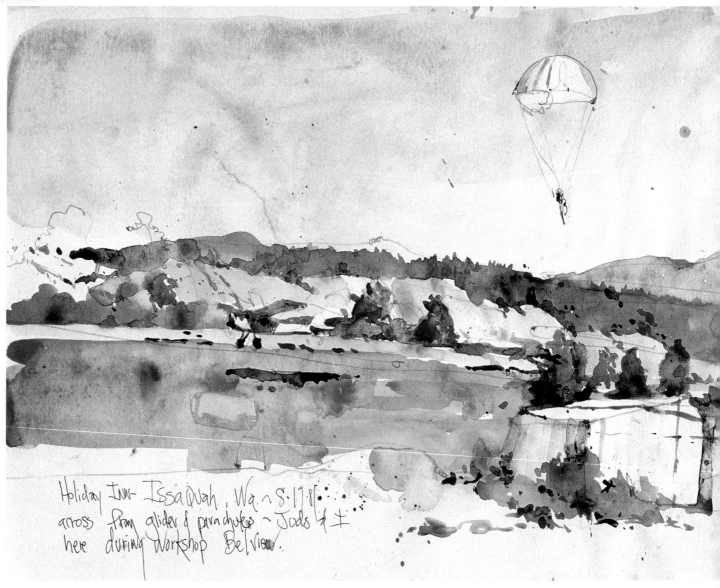

Holiday Inn - Issaquah, Wa. ~ 8.17.8[?]
across from glider & parachutes ~ Judo & I
here during Workshop Be/view.

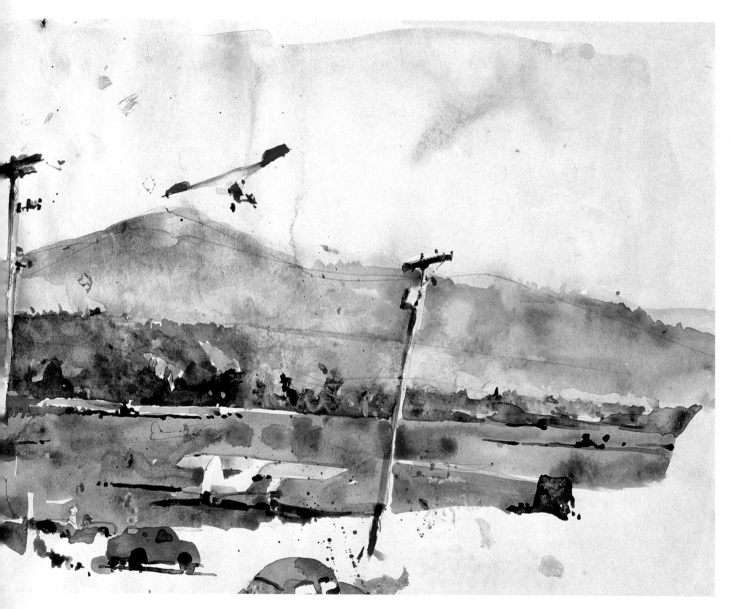

What I Like to Paint

You should paint what's offbeat. Paint things and people that you want to paint, not what you think will sell. If you paint what you think will sell, with an expected point of view, you'll paint like everyone else. Subject matter doesn't matter. Hopper and Wyeth have painted corny scenes with a personal strangeness and intensity that makes them special. I love boats and my corner of southwest Nova Scotia. I've spent twenty-five years painting variations of the same things: fishing boats, the morning sun's light and shadow on the chairs on my deck, a breakfast table of bowls, cups, decoys, fruit and flowers. Someone once said that authors have only one book to write and that all of their work is about variations on their central passion.

Buildings and Architecture

Think about your picture space and the buildings you want to include. I'm doing a close-up of a single house and want it to take up as much space as possible. A foreground object or person adds interest, but it can also fill space if I'm unable to or decide not to finish the lower part of the house.

In my Victorian house, I concentrated on shadow shapes. You have a choice of painting the wonderful detailed decoration or painting the shapes of shadows and cast shadows that give the building substance first, followed by details. Accurately painted shadow and cast shadow shapes with good tonal-values are the key.

MATERIALS

Pencil
Mechanical or repelling pencils (.07mm and .09mm HB)

Brushes
Nos. 2, 4, 6 and 8 sables

Paints
Bamboo Green • Burnt Sienna • Cadmium Orange • Cadmium Red Light • Cadmium Yellow Pale • Carmine • Cerulean Blue • Cobalt Blue • Hooker's Green • Ivory Black • Payne's Gray • Raw Sienna • Raw Umber • Ultramarine Violet • Viridian

1 Draw the Scene
Use a small plastic ruler to estimate and set the perspective lines. If you were directly in front of the house, the roof line, eaves and porch would be parallel, but since the view is slightly to the left, the left side of the roof line is slightly higher than the right side. As soon as you have a rough idea of the difference between the angle of the roof line and the base of the porch, begin contour drawing. The base of the porch is at eye level so it is drawn with a horizontal line; the higher the building, the more extreme the angles in relation to this eye-level horizontal line.

2 Begin With the Foreground Figure
Always start with the foreground figure, assuming you have a short painting time. My model is my friend and photographer Vin Greco.

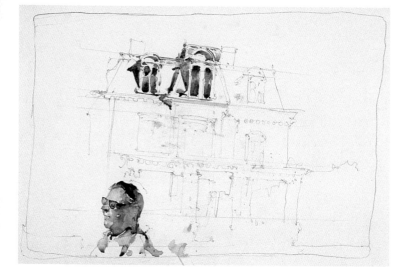

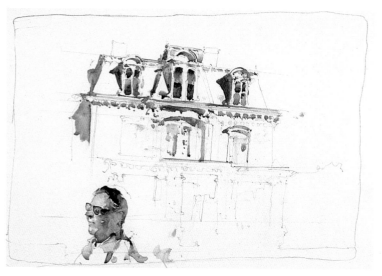

3 Paint the Darkest Darks

The darkest darks and the highest contrasts are found in the light parts of the head; the shadow parts have softer edges and less tonal contrast. You'll see the same idea as we paint the house—you always want the viewer's eye attracted to your lights.

Use a little Cadmium Red Light, Raw Sienna, Cerulean and Cobalt Blues for the skintones; and Ultramarine Violet and Ivory Black for the hair. Use Ultramarine Violet for the windows.

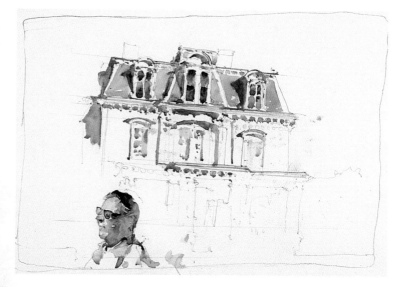

4 Paint the Upper Windows

The amount of detail for the lower part of the building is still undetermined, so start with the upper section, which is important for the sake of the composition (the upper part of building is the second element of the magic triangle). There is too much blue (Ultramarine Violet) in the center windows; temper it by mixing Raw Sienna in the arch and Raw Umber and Burnt Sienna mixed in the shadows, cast shadows and the window to the left. Mix these colors wet-in-wet on the paper.

It's good to have warm and cool colors throughout the painting. Avoid homogenized colors mixed on your palette. Add the detail under the eaves using Raw Sienna and Cobalt Blue, but try not to repeat the exact combination. Use more blue in the center arches and then Raw Sienna and Cadmium Orange under the eaves on the right.

5 Paint the Roof

Paint over the dried cast shadows on the roof using a light tone of Raw Sienna and Cerulean Blue. Don't paint the light tone first, adding the cast shadows later. It's easier to judge the correct tonal-value out in the light if you have the shadow as a comparison. It is good to work at a twenty-five to forty-five degree angle. Runs and drips are OK as long as they are a natural part of the painting process. Washes are more likely to run if painted over a previous wash.

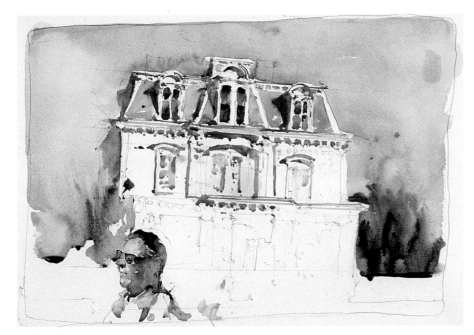

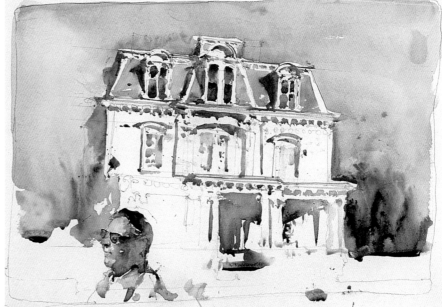

6 Paint the Sky and Tree
Start the sky using Cobalt and Cerulean Blues along the upper margin of the paper then carefully around the white trim of the house. While the sky is still damp, add the trees using Cerulean Blue and Raw Sienna on the left and Raw Sienna, Hooker's Green and Cobalt Blue on the right. Make the right-hand trees darker to complete the magic triangle—you don't want the trees to be the same tonal-value and shape on both sides of the house.

7 Paint the Shadows and Cast Shadows
Use the same colors as in step 5 to finish the windows and porch decoration. There are strong shadow and cast shadow shapes under the porch—remember, you want hard edges and accurate descriptive shapes in your cast shadows. Start with Cobalt Blue on the lower boundaries of the cast shadows, then paint up adding Raw Sienna and Cadmium Orange as you reach the porch's overhang.

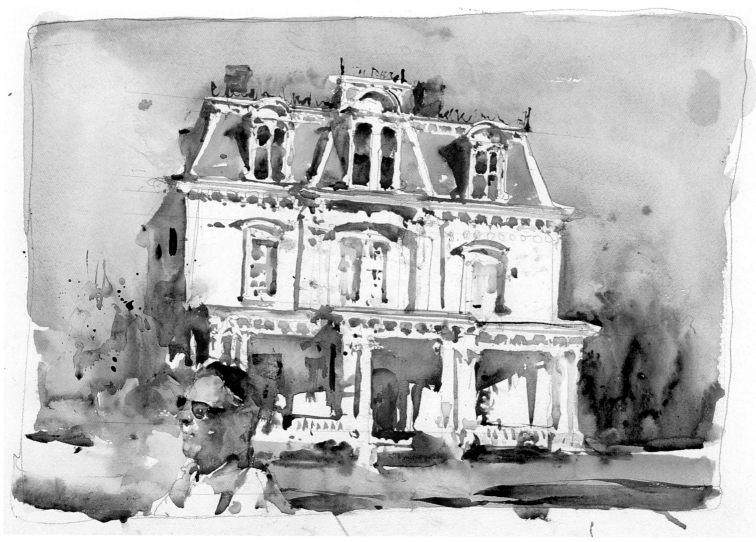

Finish

The porch's cast shadow next to Vin's head is complete, but I wish it had been simpler—without detail and lighter in tonal-value. This final stage is usually the most dangerous because of the tendency to overwork. I was trying to tie in the tones in the porch with Vin's head. I could have lifted the offending tones while they were still wet with a tissue, but I avoid correcting once a passage is dry. I used Viridian in the grass on the left and Bamboo Green with Cadmium Yellow Pale for the light grass on the right with darker Bamboo Green for the cast shadows added when the light grass was dry. The grass, front walk and porch—Payne's Gray and Carmine—were painted with both wet-in-wet and wet-on-dry.

In closing, we must assume that all of our paintings are flawed. It is troubling, but perfection is a poor alternative to making imperfect paintings that reflect our moment's honest vision.

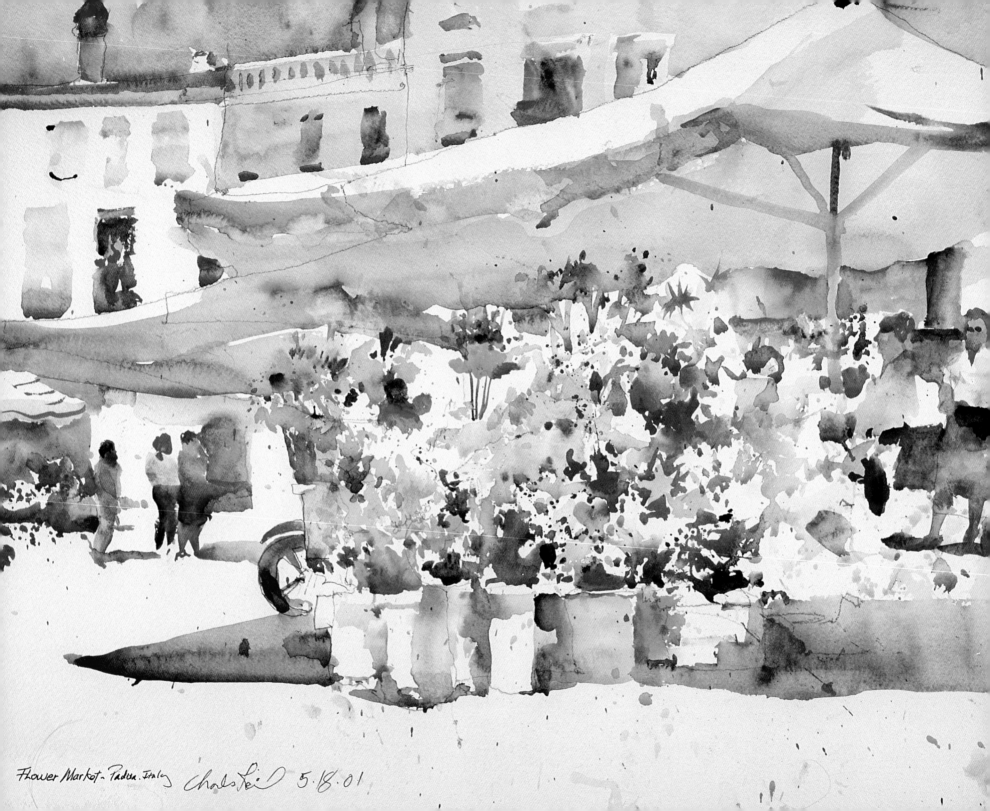

Flower Market - Padua, Italy Charles Reid 5.18.01

4 Around the Town and in the Country

I painted this sketch as a demonstration for a class on Flower Market day in Padua, Italy. If you're on your own in a European city, a painting spot is certainly easy to find, but when painting with a group, finding a spot can be a problem. Being a workshop instructor has helped me to be time efficient with no wandering about looking for the perfect subject. My two main concerns are finding a place with shade and bathrooms. On Market Days, cafés on the town square are perfect for getting good painting spots, but only if you arrive in the early to mid-morning. Most outdoor markets close down in the early afternoon. Once you buy water and coffees, you're set until the lunch crowd arrives. Remember, the café staff will be happier if you plan on lunch.

If you plan to work from life, you must go for a finish with each person or section on your first try. Don't plan on a panorama; you'll be frustrated. Leave any light tonal-value (any tone that seems vague, grey or off-white) white paper. Concentrate on definite color/value shapes and any adjoining background dark shapes that explain or describe a foreground light shape. Use brighter pure color in your reds, oranges and yellows than you would normally.

Make the Most of Your Time

Sketchbooks taught me about the importance of time (actually, the lack of it) needed to make a good drawing or painting while working on the spot. I learned that I didn't have time for sketching with searching lines; I needed a single, carefully considered contour line to capture my subject or scene. Slowly my drawing improved. I started painting in sketchbooks in the late 1970s, using the same light drawing paper, and found that I couldn't correct or use overwashes on fragile sketchbook paper.

This changed my approach to all of my watercolor painting. Even when I paint with heavier watercolor paper, I strive for the correct tonal-value with my first try. I don't always manage a finish with my first try but it's always my goal.

Flower Market, Padua, Italy

Painting Backgrounds

Backgrounds are always the hardest part of a painting. A background should support your subject but not dominate it. A very green English lawn surrounded my still life, and it scared me (I always ask myself if something in the background is essential or potentially dangerous). If the answer to this question is "dangerous," I leave it out.

Find points of precise painting—
they give the impression of precision
throughout the picture.

Painting Flowers

I tend to ruin sketchbook pictures if I don't leave things out. I wanted to suggest the still life's surroundings so I left a hint of the grass, hoping the white paper would complement the flowers rather than dominate them. With John Singer Sargent in mind, I concentrated on the doorway and painted it as well and completely as I could, then simplified as I painted away from the doorway.

Urchfont Flowers

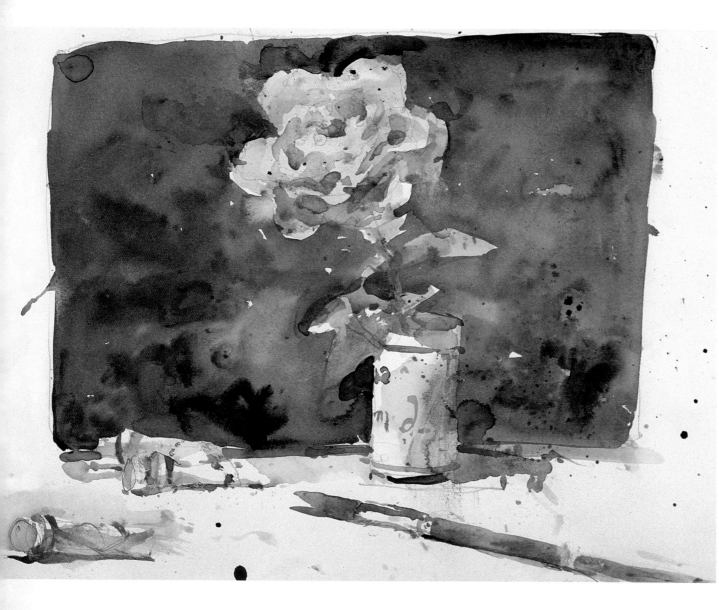

Don't Copy Your Image Exactly

Think of what's needed to show your idea but never copy what's there. I needed the large rectangle of dark to show the light rose and pot but liked painting the paint tubes with subtle shadow and cast shadow shapes in the paint tubes with their stripes of color against the white paper.

Look at a rose or any large-form flower, then look away and write your impressions. I think you'll remember color, lightness and delicacy but never dark details. My dark ground helps this painting. No tonal-value within the rose can be as dark as the dark background. Hold a light-valued flower up against a dark background, squint and compare the darks within the flower to the dark background.

When you have a very light flower you'll need a darker background or the flower will be lost. I like to have the appearance of lightness—sometimes I make a contained, darker background around my subject then white paper around my dark background, foreground and tabletop objects. One of the hardest things to do is not paint over your whites when you see a tone. Keep white paper until the very end in light to mid-light areas. Then decide if you need to add a light tone. Someone once called black "The Prince of Colors." Let's call white "The Princess of Colors."

Flowers and Paint Tubes

Exercise
Paint What You Have

If you're ever at a loss for a subject or challenge, set out some paint tubes and a couple of brushes on a piece of white paper under a single light source. You'll be amazed at what you'll learn from this simple exercise.

Catching the Spirit of a Scene

My sketchbook work is now on heavier paper (I use Art Xpress watercolor sketchbooks). These sketchbooks can take a moderate amount of reworking, but I still find first washes are always best—lightly mixed fresh paint is always better than tired color from a mixing area.

Catching the special spirit and mood of a place makes a sketchbook painting memorable. I painted the crew with Cobalt and Cerulean Blues, Cadmium Red, Carmine, Raw Sienna, Viridian and Ivory Black. You should always find some neutrals when painting with pure color. The pure color and tonal contrasts in the crew were painted first, making it necessary to place pure colors in the buildings.

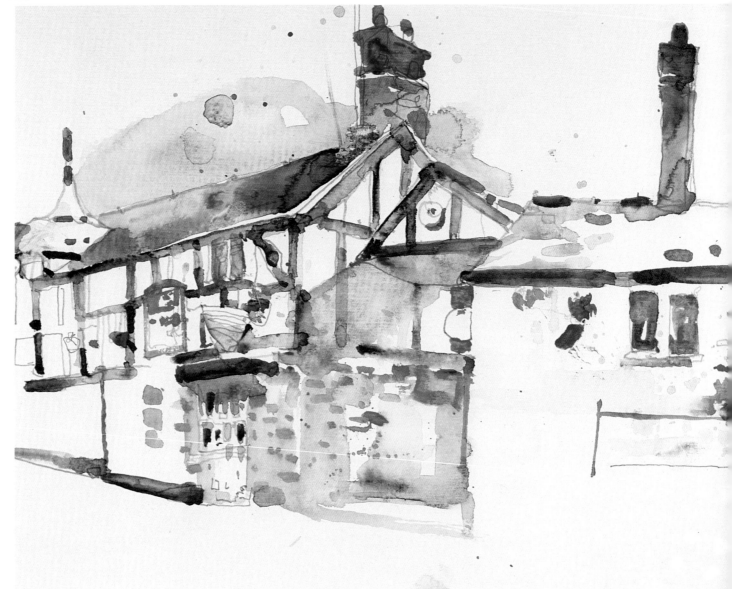

Find the Color
Study *Mustering the Crew* and find where I used pure color as well as some slightly mixed neutral colors. Also look for the places where I used dark tones from my paint supply.

Mustering the Crew

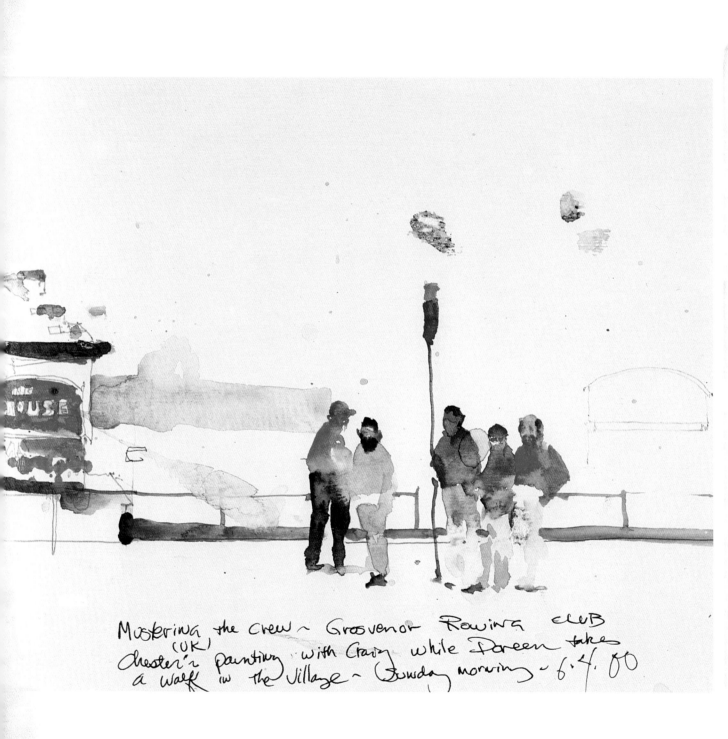

Mustering the crew ~ Grosvenor Rowing Club
(UK)
Chester ~ painting with Crazy while Doreen takes
a walk in the village ~ Sunday morning ~ 6.4.00

Color Combinations

I used these same colors in the building, along with Cadmium Orange, Burnt Sienna and Cadmium Yellow Pale. I choose a color from the paint supply that most matches the tonal-value I see. A light blue tonal-value would call for Cerulean Blue while a dark blue would be Ultramarine. Adding Carmine or Burnt Sienna to the Ultramarine Blue will give you an even darker tonal-value. Cadmium Red comes from the tube at a mid tonal-value; to darken go to Carmine, Burnt Sienna or Burnt Umber. Adding a green will also make your reds go deeper.

I rarely add water to Cadmium Red to lighten since the result looks sickly. Instead use Carmine with water or try Cadmium Yellow Orange.

I used Ivory Black, which is unusual for me. In most cases I mix the black wet-in-wet on the paper using Burnt Sienna, Carmine or Cobalt or Ultramarine Blue. Diluted black is also unpleasant, so try to use the above colors with water to lighten, or better yet, avoid black in your lights altogether.

Try to use some colors directly from the tube when you can find a tonal-value match (try painting one-third of your painting with pure color). Don't feel you must always mix a second color or use lots of water for fear of the color being too strong.

Try mixing mid darks and darks on the painting rather than on the palette. You may have to work out the colors on the palette, but you must always see "the makings" rather than a homogenized gray puddle. Continue to clean your palette so you're forced to use fresh paint.

Editing Your Composition

There's an early Edward Hopper oil painting of a building in Paris where he left out all the windows, leaving a wonderful, uncluttered and light-filled picture. There are so many dark windows and dark green shutters on French buildings. You need to leave out some, lighten others and use some diluted blue instead of green in some of the shutters. Look for cast shadows next to shutters so the dark windows don't seem like isolated spots. Paint for simplicity and light and avoid clutter.

Painting Buildings
When you paint a building, use darker tones and detail toward the top. Simplify and lighten the middle section and then use darker tones and more detail at the base.

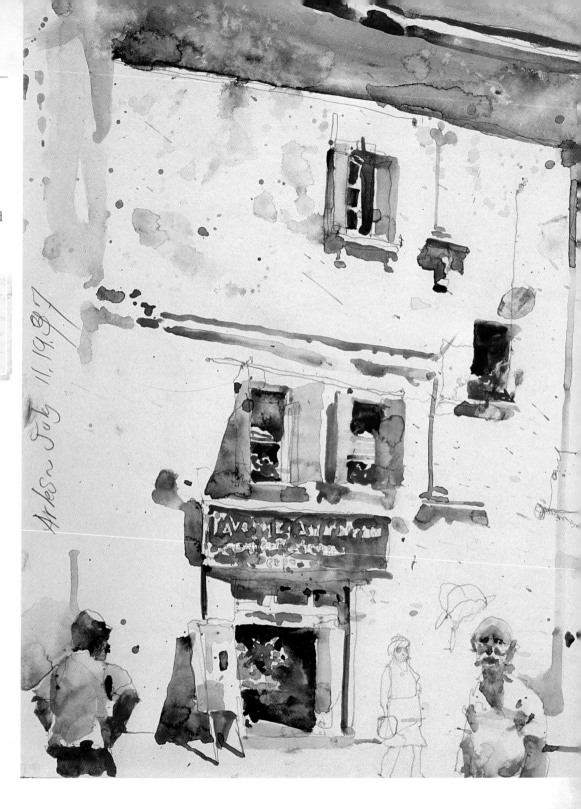

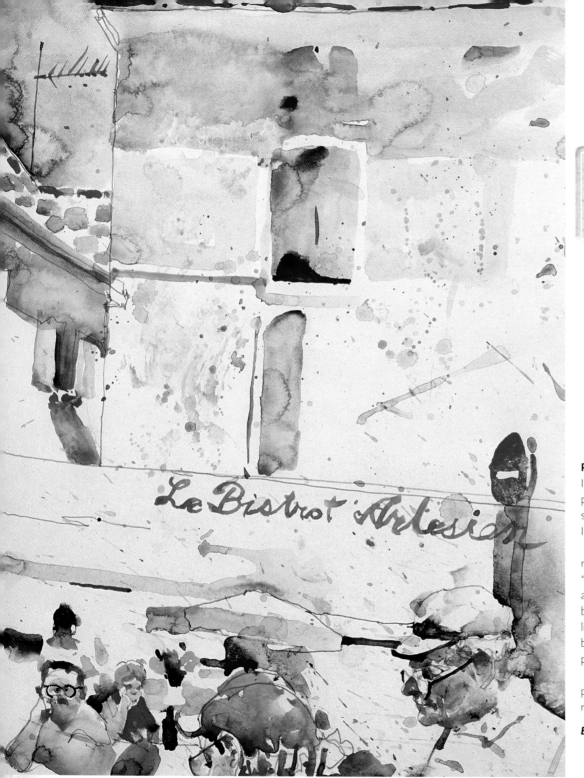

Shapes

You want carefully seen and accurately painted shapes. Make sure you can paint accurate shapes before trying to soften them.

Positive and Negative

I try for half positive shapes (the darker shape I'm painting) and half negative shapes (the darker shape next to or behind a lighter positive shape I'm painting).

Cast shadow shapes can be both positive and negative, but don't go crazy over the confusing "positive and negative" thing. Just don't overwork a light area; instead, look for something dark behind it. I painted the sign on the left using light-positive letters with a red/Carmine negative background. The Bistro Artésien letters were painted with dark positive letters.

My sketchbooks are a diary, so I date and place the pages with an often careless hand and no artistic merit.

Bistro Artésien

Painting Negative Shapes

A positive shape is most often the subject you're painting. If your positive shapes are very light, leave them the white of the paper. Don't paint them first with a light tone, first paint a darker negative (like the background) shape next to or around your light shape. You can add a light blush of color over your white shapes, making sure you don't disturb their sense of lightness.

My Skiff and Ron's Traps

When you have a dark positive shape (like my skiff), paint it dark with your first try. When you have light positive shapes (like the lobster traps) and you can see darker shapes around them, leave your light shapes white paper. Paint the dark from the background so you can "see through" the shapes, but don't make them too dark or solid. Small, negative dark shapes have to breathe and need to have subtle tonal variation. Add dark pigment wet-in-wet to your small, damp negative shapes to achieve an accurate look.

Ron is the last of the fishermen in Baccaro who still use wooden lobster traps, and he rows his skiff down our creek to his fishing boat rather than driving a pickup truck.

My Skiff With Ron's Traps

My skiff with Ron's traps & Crow Neck Baccaro ~ July 1986

86

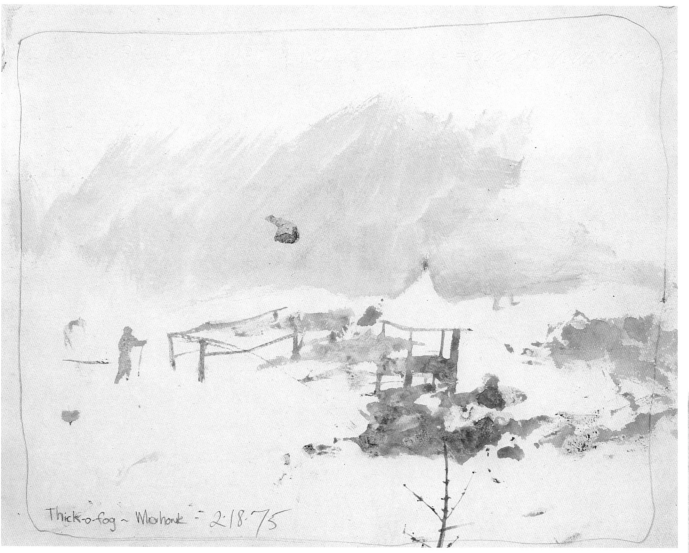

Thick-o-fog ~ Moohonk ~ 2·18·75

Painting With a Triad

I used a very limited palette: Ultramarine Blue, Raw Sienna or Yellow Ochre and Carmine or Alizarin Crimson. This is the basic triad: a red (Carmine or Alizarin Crimson), a yellow (Raw Sienna or Yellow Ochre) and a blue (Ultramarine Blue). I didn't make a pencil drawing first but used nos. 4, 6 and 8 fine-pointed brushes. I used these three colors to create a range of grays.

Thick Fog, Mohonk

Exercise
Painting Negative Space
Try having one section painted with negative shapes (like the background gray that forms the cupola in Thick Fog, Mohonk*). The rest was painted with positive shapes. Try to connect all of your shapes, finding one shape that is darker than the others. Make a path through your painting with connected shapes.*

A Study in Grays: Snow Scenes
Snow scenes are the best introduction to landscape painting, providing easily seen shapes and contrasting local-tonal values without much color. A typical snow scene is a study in grays set against a white paper background. We often worry too much about color and don't think enough about contrasting tonal-value shapes. See and paint contrasting tonal-value local-color shapes—this is the key to successful painting.

Creating Interesting Buildings

Buildings are by nature symmetrical with definite boundaries. However, symmetry and definite boundaries make uninteresting paintings. Never paint your mind's conception of a building. Instead paint a collection of beautiful colors and shapes that suggest a building.

Problem

I'd left a white paper section in the building for David, but I think three important elements—roof, doorway and David—are too competitive. It would have worked better with the roof and David as they are but the doorway lighter in tonal-value.

Building First, Figure Second

I varied the tonal-values of the roof boundaries and mixed Ultramarine Blue and Burnt Sienna and let the colors mix on the paper. I painted the building before adding David, starting in the doorway. Sometimes it's better to have importance within the building rather than emphasizing the building's static outside boundaries. I used a mix of Cerulean or Cobalt Blue, Carmine and Cadmium Yellow Orange (Holbein), again mixing the colors on the paper. For the bushes near the doorway, I used Oxide of Chromium with touches of Cadmium Yellow that were added wet-in-wet.

David Connolly Lately of the HMS Sea Wolf at Urchfont Manor

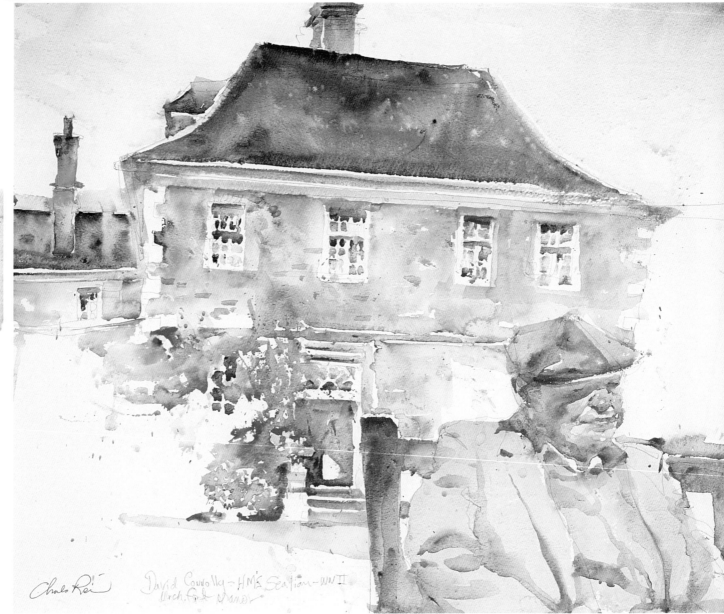

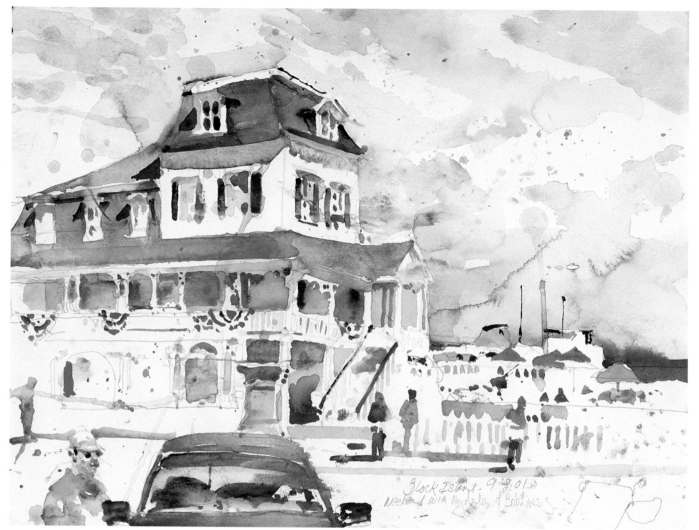

Block Island 9.8.01
Weekend with my dates of Bobtimes

89

Exercise
Painting Block Island

I've used some pure color but it is more important, if you're new to painting, to concentrate on the shapes and values—try a simple mix on your palette of Cobalt Blue and Burnt Sienna or Burnt Umber. Any color mix you come up with is fine. Small is good—outline several 6" x 8" (15cm x 20cm) rectangles on a piece of watercolor paper. You don't need much drawing (see my next chapter on direct painting) using your mix with your photo or my painting of Block Island. Turn your reference upside down and paint the local tonal-values of the roofs and shadow and cast shadow shapes. Try to connect your shapes so they're not isolated but actually flow through the picture.

Seeing Light and Shadow

Whenever possible, paint buildings in sunlight with easily seen shadow and cast shadow shapes. Seeing shapes rather than things is an abstract idea that may be difficult and foreign to you. Try taking a photograph of a white building on a sunny day without a flash. Assuming your photo has shadow shapes, turn it upside down and paint the shapes you see (upside down helps you to not think of it as a building). Now turn your version of *Block Island* upside down and compare it with your photo.

Block Island

Painting Variations of a Landscape

I've painted this meadow in Urchfont, Wiltshire many times. It's amazing how many variations one can find working from the same scene. Compare these two paintings. They were painted in the same location at different times and from different positions. Last Evening at Urchfont has a better design with fewer shapes and subtler colors. Urchfont Meadow has too many shapes and the colors are rather harsh—the grass appeared that green even with a threatening sky. The Ivory Black in the clouds is a bit much; a gentler Payne's Gray would probably have been better. Don't be afraid to paint the same subject matter repeatedly—you can vary the scene a lot.

> I'm really trying to paint the day and how I responded to it.
>
> ❊

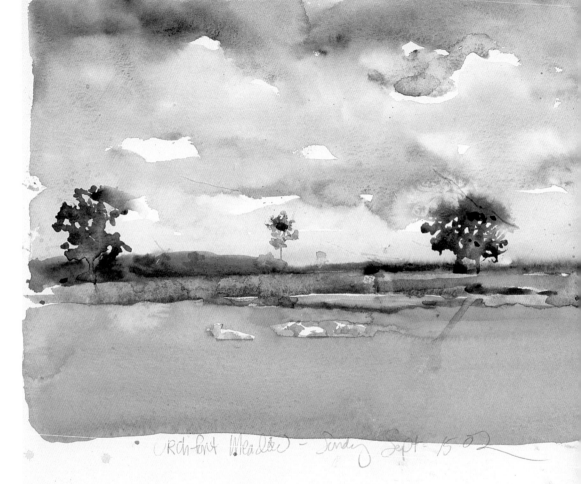

Vary Your Composition by Adjusting Your Point of View
I vary my compositions by changing my painting spot and using horizontal and vertical formats, but the important differences are in specific cloud formations and the effect the changing light has on the colors and tones in the landscape. I'm really trying to paint the day and how I responded to it. This is the real value and pleasure of on-the-spot sketchbook painting. I rarely take a camera on my trips, because I find myself copying the scene in the photograph rather than the day, missing the flaws and clumsy but truthful passages in my on-the-spot painting.

Urchfont Meadow

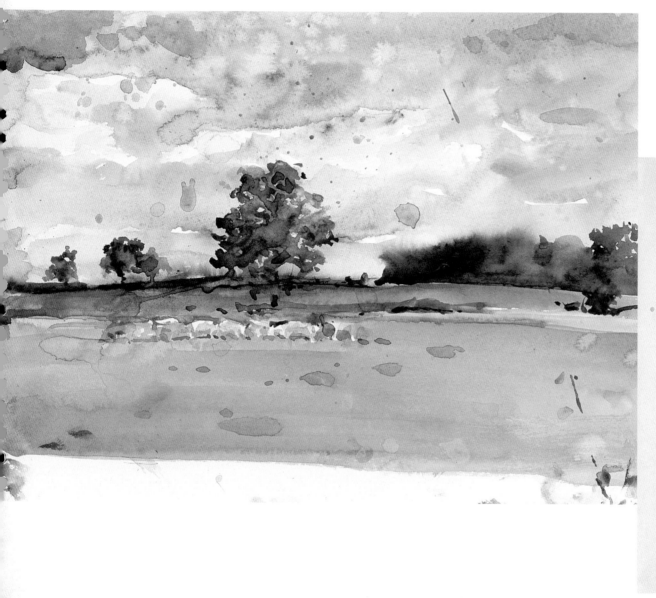

Don't be afraid to paint the same subject matter repeatedly—you can vary the scene a lot.

❀

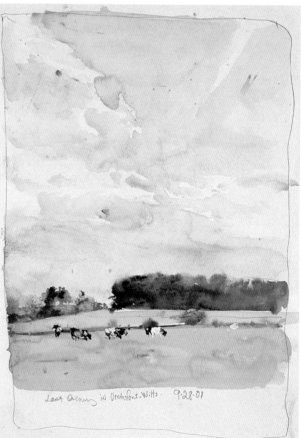

Last Evening in Urchfont. Wilts. 9.28.01

Last Evening at Urchfont

91

Direct Painting Without a Drawing

The trick to direct painting is to do the drawing in your mind and then arrange the spots of local color and tonal-value so they look like a person or object. It may sound scary but this is the way kids paint before they become self-conscious. Join flat shapes of local color/tonal-value with a careful eye for correct placement. Give the illusion of spontaneity, painting very deliberately.

Exercise
Paint Contrasts

Paint a picture with light against light, dark against dark, light against dark and dark against light, as I did here.

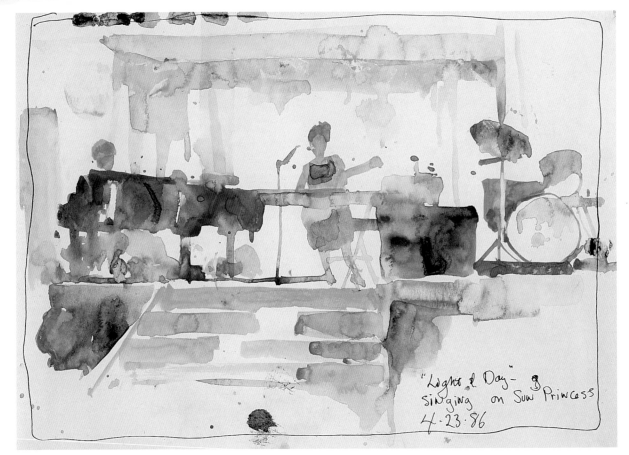

Light and Day

I painted this one evening aboard *The Sun Princess* while teaching classes in the Caribbean. As I recall, the room was rather dark. I used a small hand palette with an attached water container and a no. 4 sable travel brush. My sketchbook paper was light, more for drawing than for painting. I've found that some students do their best painting without a drawing on light paper. The lack of drawing and the casual paper might make for less self-conscious and more natural pictures.

It's necessary to be able to see shapes and paint them accurately on the first try—no corrections are possible on this light paper. Also, you must be able to let one darker shape merge with another without stopping. In *Light and Day*, the couple performing, the piano and most of the stage (except for the drum) are painted as positive shapes. I've stressed in other parts of this book the need to paint negative shapes along with your positives. Unfortunately, nothing is always true in painting. It's easier to concentrate on your positive darker shapes if you're working without a drawing. If you find working without a drawing works for you, start adding more negative shapes.

Light and Day

92

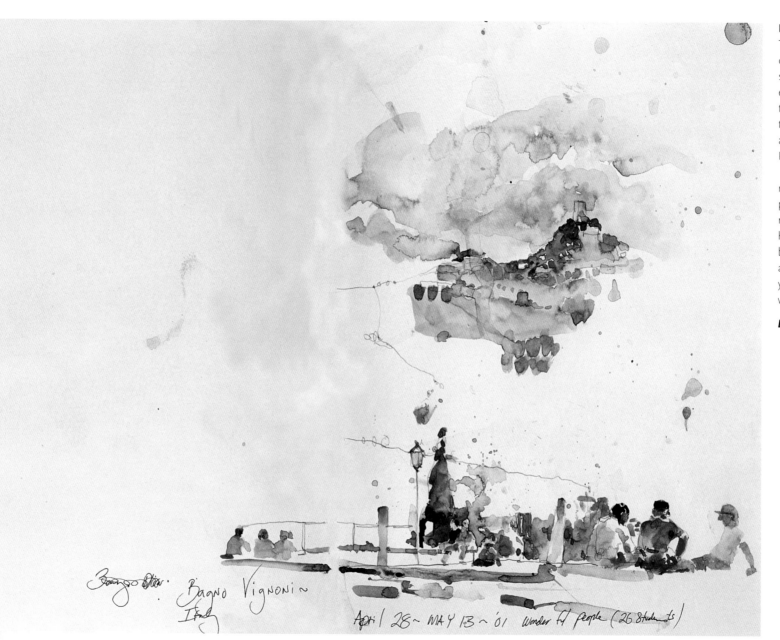

Bagno Vignoni
This painting uses all positive dark shapes. I had light and shade, so I needed some darker background negative shapes to show my lights in the foreground. When you have a light to paint, don't paint it. Paint the dark behind it instead.

There are two separate segments. First I painted my people. Then my eye went to a medieval castle on the distant hill skipping the green space in between. A sketchbook has the advantage over the camera—you can be selective and paint what's important to remember.

Bagno Vignoni

Bagno Vignoni, Italy

April 28 ~ MAY 13 ~ '01 Wonderful People (26 Students)

93

Direct Painting Flowers

Use the drawing as a guide to make you aware of the importance of specific shapes—you mustn't think of drawing as filling in outlines. Make sure that the silhouette of your arrangement isn't symmetrical. Use the outside border to plan the amount of space around the arrangement, connecting the vase to the border in three places.

Never draw a subject in a vacuum; always think of the amount of space around your subject and think of how you'll handle it. Backgrounds are always hard. If the background doesn't interest you, have the bouquet take up as much space as possible.

Perfect Pitch

When you paint flowers and figures, you'll need to deal with subtle color changes, using perfect pitch with your tonal-values.

MATERIALS

Pencil

Mechanical or repelling pencils (.07mm and .09mm HB)

Brushes

Nos. 2, 4, 6 and 8 sables

Paints

Cadmium Orange • Cadmium Yellow Orange • Cadmium Yellow Pale • Carmine • Cerulean Blue • Cobalt Blue • Hooker's Green • Ivory Black • Olive Green • Permanent Rose • Raw Sienna • Raw Umber • Ultramarine Blue • Ultramarine Violet • Viridian

1 Draw the Flowers

Concentrate on making accurate shapes—don't generalize and don't sketch. Draw slowly, never lifting the pencil. Draw some flowers as outside shapes and others with the outside shape continuing into individual inside petal shapes. You will draw and form many of the shapes as you paint, so don't get too involved with details.

2 Paint the First Flowers

Start with the top flower and mix Cadmium Yellow Orange with Permanent Rose. You want the petal closest to you lighter, so leave a very thin buffer of white paper so the darker petals won't bleed in. Add a green of your choice for the stem while the flower is still wet. Use the same colors in the second flower if you wish.

Pinks

Pinks are difficult. I don't have Permanent Rose on my regular palette, but I do squeeze out a bit on the mixing flap next to my Carmine.

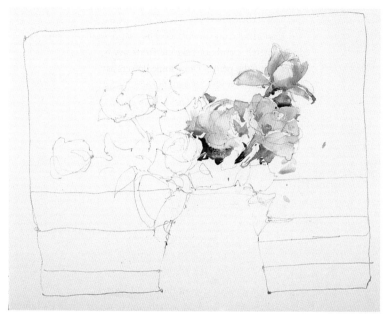

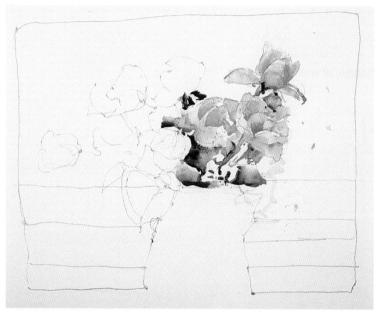

4 Add Some Darks
Paint the greens with hard edges where the greens meet a light flower. Use Viridian and Olive Green but also mix some greens with a blue and Cadmium Yellow Pale—experiment, mixing various blues with your yellows and Raw Sienna.

The darker shapes within the roses aren't dark. Keep the overall spirit of the delicate, light nature of the flower even as you add darker shapes. Don't use complements in your darker flower shapes—they make the darker shapes too dark. Use Cadmium Orange from the tube with just a little water for the darker shapes.

3 Add More Flowers
Leave the lightest parts of the light-valued flowers white paper. An overall first wash can lose very delicate lights unless your first wash is very light, which will mean the overall flower will appear washed out. Try to connect the flowers, leaving islands of white paper. You can always add a very light blush of paint for the lightest lights after the flowers are dry. Add your green stems while the flowers are still wet.

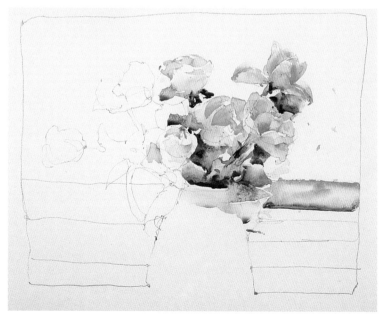

5 Add More Darks
Use the same colors and approach you did in Step 4. Most of the light orange, Cadmium Yellow Pale and Permanent Rose washes are mixed on the paper still holding onto the white paper shapes within the flowers. Leave a white paper rim in the top of the vase, but let the green seep into the front of the vase, which is in shadow. Add Cobalt Blue and use the blue, watered green and a little diluted Cadmium Yellow Orange to make the gray in the upper part of the vase.

6 Add the Vase and Background

Add a window frame of Raw Sienna with a stripe of Raw Umber and a little Ultramarine Blue along the lower edge painted wet-in-wet. Try not to finish the flowers before dealing with the vase—use diluted Carmine with a Cobalt Blue stripe down the center. Paint a darker background shape next to the vase; press the brush about half way to the ferrule so the tip runs along the base of the wash. The wash is a negative shape that enhances the light vase. Notice how some blue from the vase leaked into the background blue (Ultramarine Violet). Make sure that at least one part of each form leaks into an adjoining form. No shape should ever be completely contained without an escape route to a neighboring form.

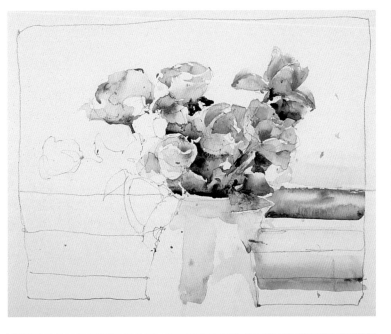

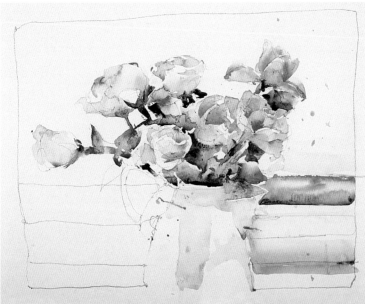

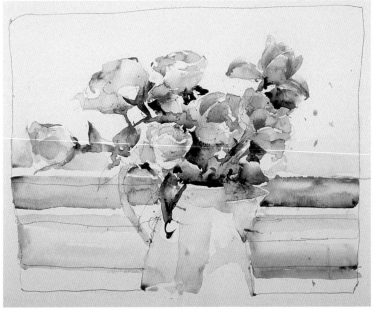

7 Finish the Flowers and Greens

Vary the greens in tonal-value, coloring some parts lighter and some darker so they don't isolate the lighter flowers. Don't mix up a homogenized puddle green on your palette. Instead try mixing your greens on the paper, using different green combinations throughout. Try Viridian, mixed with Cadmium Yellow Pale or Cerulean and Cobalt Blues along with Hooker's and Olive Greens. Never have a formula for your greens; it's a tough color, and you'll have to find a combination that works for you every time you paint. If you used too much water, don't dab with a tissue. Shake the brush and add pigment, with no additional water, wet-in-wet to the wet area. Naturally, stopping drips at the bottom of the problem with tissue is fine.

8 Finish the Window Frames and Vase Handle

Use Carmine, Raw Sienna and Cerulean Blue to finish the window frames and add the vase handle. Notice how the left side of the vase merges with the window frame—this is what you should see when you squint. When squinting at the right side of the vase there is a separation between the vase and window frames. If a boundary is hard to see, you'll lose it regardless of area identity. If a boundary doesn't disappear when you squint, you'll have a harder edge and a separation between the two adjacent forms.

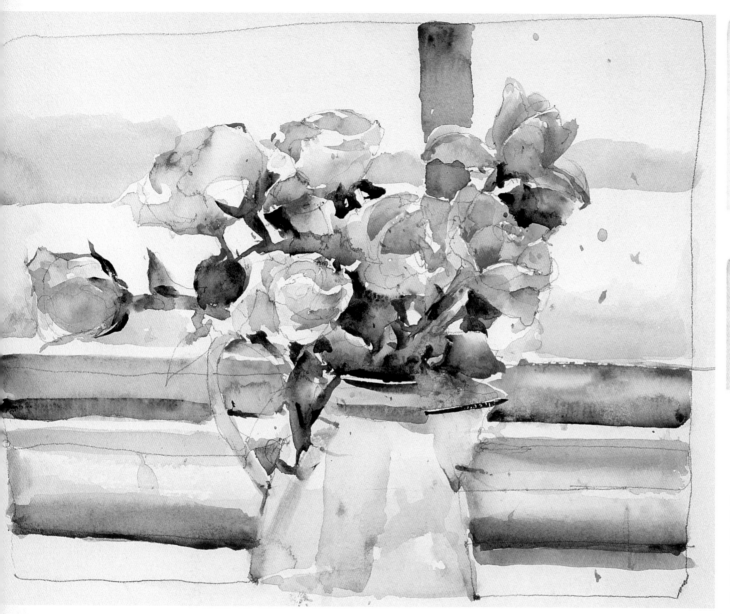

The Background

I wanted to concentrate on the flowers and didn't add a background in the beginning. If you plan on a background, paint it as you're painting your subject; never add an important background as an afterthought. Here I made the merest suggestion of trees by leaving white paper so I wouldn't change my original idea. I'd never fill in a whole background with a neutral tone because it could deaden the whole painting.

Blacks

Use only blacks or neutral darks mixed by combining cooler blues, either Cobalt or Ultramarine Blue, with Burnt Sienna or Burnt Umber (warmer). Occasionally, blacks mixed with a yellow or Raw Sienna make good greens.

Finish

Use Ivory Black in the spout of the vase, again wet-in-wet on the left and with some Cobalt Blue on the vertical window frame. A stripe of pure but diluted Ultramarine Violet hopefully brightens the lower right window frame and repeats the blues and violets in the vase.

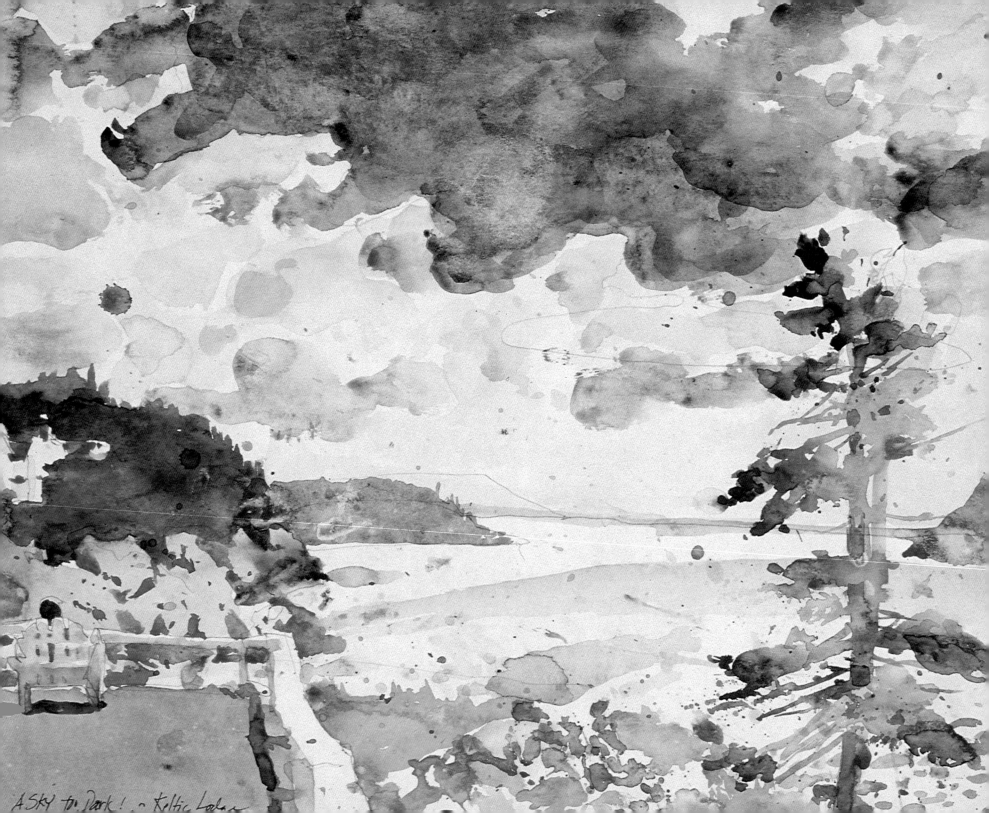

A Sky to Dark! ~ Keltic Lodge

5 Seasides and Waterscapes

In this section I'll mention the gear I carry when I work outside and make suggestions for painting people on the beach and beside a swimming pool. I work directly with or without a quick contour drawing, finishing one person at a time, not painting the person as much as the shadow shapes that create a person on the paper. I'll also discuss planning your painting time and how sunlight plays such an important role. Nature is my inspiration, but nature can't be copied so I usually pick colors and tones that might enhance the picture rather than the colors and tones I actually see. Painting the light and shadow, as well as the darker shapes, accurately is a recurring theme. Can you forget the physical subject and paint only light, middle and dark shapes?

Capturing the Surf

Painting the ever-changing surf patterns as the ocean meets the beach is a difficult quest. Winslow Homer is the master of simplification as well as my guide to painting sea, surf and sand. Homer's *After the Hurricane* is a complete lesson in simple tonal-value separation. John Singer Sargent is a wonderful waterscape painter, but his skill is amazingly daunting. His watercolors are filled with subtleties too difficult and confusing for most of us. Since I think simplicity is our ultimate goal, I suggest copying and admiring Homer and looking to Sargent for inspiration.

Cape Breton, Nova Scotia

Painting at the Beach

First, you'll need an umbrella. You shouldn't try to paint with your paper in direct sunlight because it's hard on the eyes and makes it difficult to see tonal-values. Plus, the paint dries too quickly.

I never use an easel when working in my sketchbook. I work with my sketchbook on my lap in a folding chair with my umbrella shielding me. An easel draws attention; it's best to blend in with the other beach-goers.

There's no time for layering washes, so start painting with mid and dark values, leaving the paper white for your lights. I use a mechanical pencil, HB 0.7mm or 0.9mm. I begin with single line drawings then immediately paint and complete a figure or subject before moving on. Always attach cast shadows to your subject's shadows.

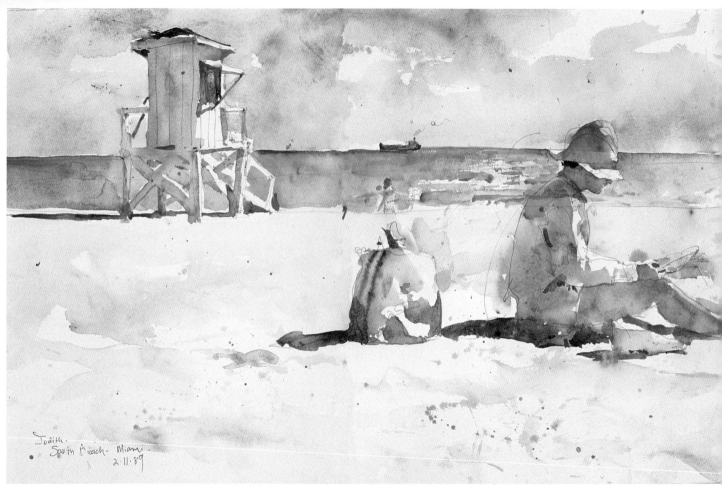

Shadows and Cast Shadows

Shadows and cast shadows should always be seen as connected shapes, painted wet-in-wet, at the same time as your subject. I paint the shadow first, down to its intersection with the cast shadows. Then, starting at the cast shadow's farthest point, I paint the cast shadow back to meet the still-wet shadow shape.

Judith at South Beach, Miami, Florida

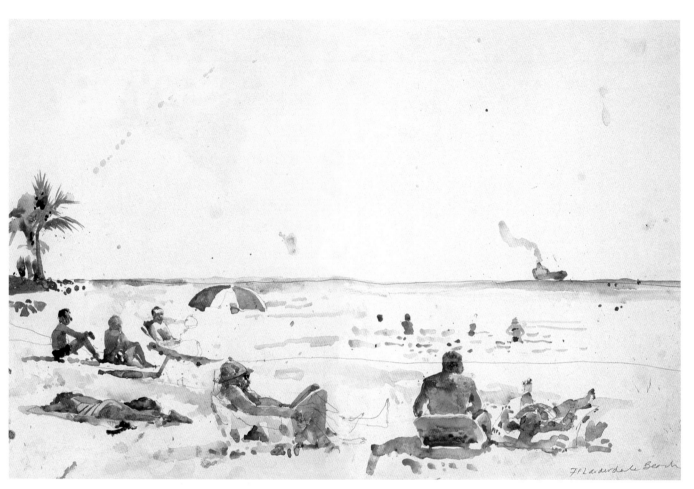

Make a Plan Before Painting

I spend some time studying the figures closest to me and decide which ones seem likely to stay put for the necessary time, usually five to eight minutes. I complete each figure, chair and shadow shape before going on to the next figure. I start with my darks and mid-valued darks; I deal with my lights last, sometimes leaving the lights white paper. Occasionally, I add a light tone when my darks are dry. You must lose or soften necessary edges before your darks have dried. You'll notice that I don't always follow my brief drawing. The woman in the blue hat moved her legs, so I painted the new leg position without a drawing.

This painting's process differed from *Judith at South Beach*. I see that Judy's shoulder is painted over the water. It would seem that the lifeguard stand, the sand and ocean to the left of Judy were painted, then I decided to get Judy to pose—not very good planning. The whites in the hat and shirt are white paper (not opaque white paint) so it's a bit of a mystery.

Beach at Fort Lauderdale

Capturing Dramatic Light

The early morning, late afternoon or evening are the best times for capturing dramatic light. You must work small and finish the parts that are most likely to change by the minute, as the sun moves.

Plan your white reflections with pencil—they change by the minute. Stick with your penciled reflection plan even though the reflections move across your scene. The patterns will stay with you until the sun rises too high.

Sloop of Tobago

I had seen a large sloop at anchor the previous evening. I wanted to paint this scene, so I prepared my painting stuff. I drew Little Tobago (the landmass), the horizon and shore before turning in for the evening. In the morning, I started just as the sun was behind Little Tobago, drawing the white paper oval for the sun higher, knowing it rises with amazing speed. I painted diluted Cadmium Yellow Light around the oval, then Cobalt Blue, keeping the blue close in tone to the yellow but slowly darkening the blue as I painted away from the sun. This has to be done wet-in-wet with the first wash.

Little Tobago

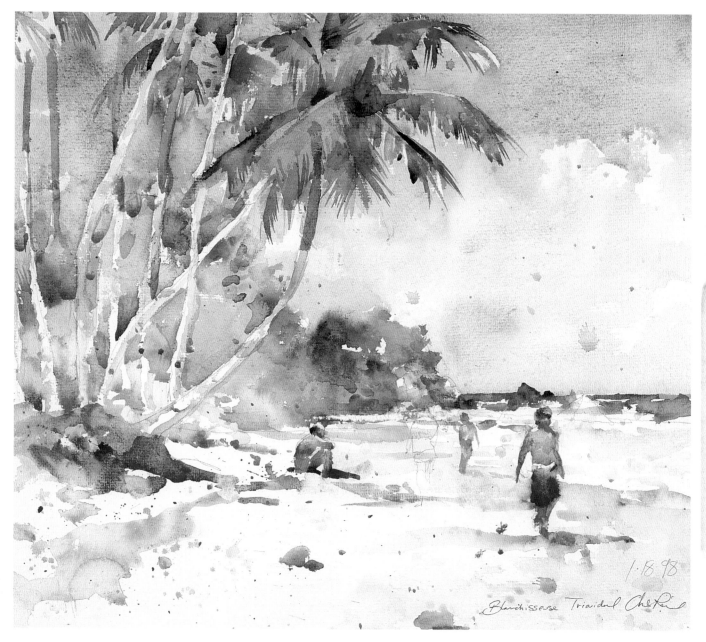

Simplifying Sunlight

Nature is too complicated to copy successfully so you must distill what you see into your personal impression. This means you can't just paint what you see. In Blanchisseuse, the trees behind the palm trunks were very dark. I wanted a sense of sunlight and felt that darks behind the light palm trunks would make the painting too heavy and distracting with too many contrasts.

Instead, I made a blue spot of color at the base of the palms to anchor the left side of the painting. Squint and see how spots of dark and color lead your eye across the paper and through the picture.

Blanchisseuse, Trinidad

Different Light, Different Shadows

Morning and afternoon sunlight create longer cast shadows that can tie together elements in your painting and become important design additions. (Remember, shadows and cast shadows are as real in paintings as objects or people.)

Never continue painting a picture with morning shadows in the afternoon. Never change shadows as the light changes. You must finish each section of a sunlit painting rather than working throughout the painting. Don't worry if cast shadows are changing as you work across the painting—only the picky will notice.

103

Adding People to Beach Scenes

The sky in Trinidad can change from pristine Cobalt Blue to monuments of light cumulus clouds to dark, low rain-filled clouds, all within the space of an hour. The color of the water turns from turquoise to Payne's Gray, mirroring the mood of the sky. The rock's local color changes in the same way. It's apparent how color and tonal-value change radically as the sun moves from light to shadow. The surf also changes depending on the moment you choose to paint it. I painted a sea full of breakers in *Douglas* and a simpler blue sea in *David* using Payne's Gray and Peacock Blue (Holbein) with a strip of white surf containing bits of suggested darker shapes within the white. Don't destroy the "whiteness" of the surf as you add bits of subtle value changes.

Using Local Models
I dislike stock figures without particular character, so I hire local guys to pose for thirty minutes and give them ten-minute breaks. When David took his break, he bent his head. He was busy for five minutes, and I wondered what he was doing. His posture made me wish I'd used a more natural pose. David, back in position, happily smoked and could have posed on and on.

David, Grand Riviere, Trinidad

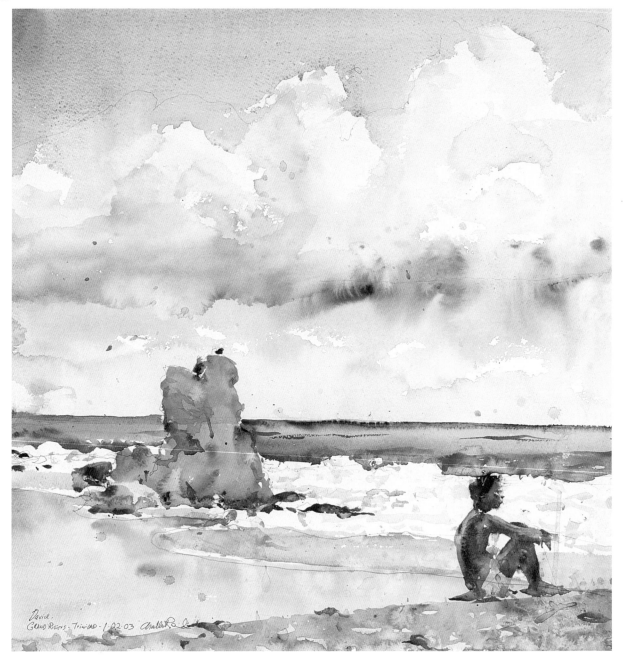

David.
GRAND RIVIERS - TRINIDAD - 1-22-03

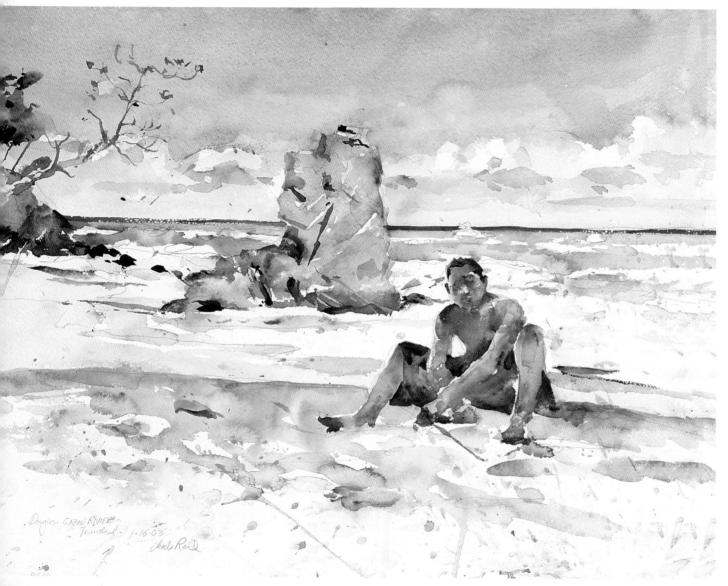

Always paint your darks first when painting dark complexions. Reserve the highlights in a dark complexion.

✻

Douglas, Grand Riviere, Trinidad

105

Starting With a Single Figure

This looks confusing, but I started with a single figure and painted the dark adjacent negative background shapes. I kept adding new figures and their adjacent negative darks. Never randomly work on figures around the page. Always work away from your starting figure, painting around and away from him or her. Painting takes patience—this spread took about four hours.

Weave Your Darks and Light

Think of weaving a tapestry of shapes of lights and darks. I look for a person who seems settled, then make a single line with a mechanical pencil with my paints ready to go as soon as I am finished drawing. Always include small bits of adjoining negative shapes and cast shadows. Don't "spot" separate people around your page; instead, paint a second person connected with your first using interconnecting negative darks and lights.

Key West Pool

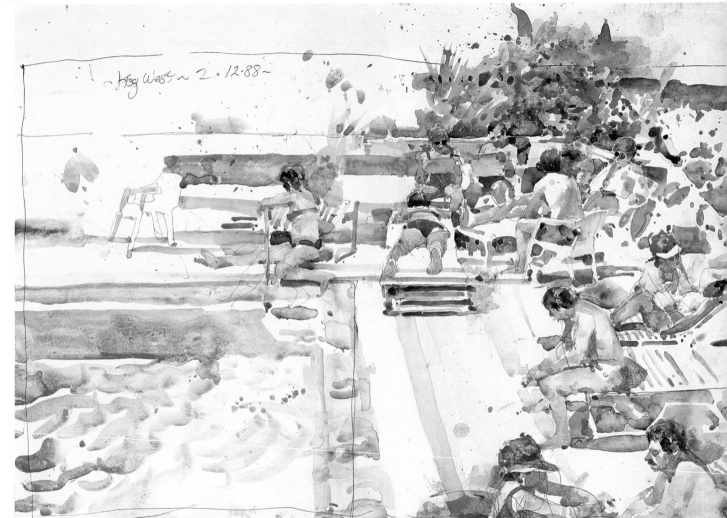

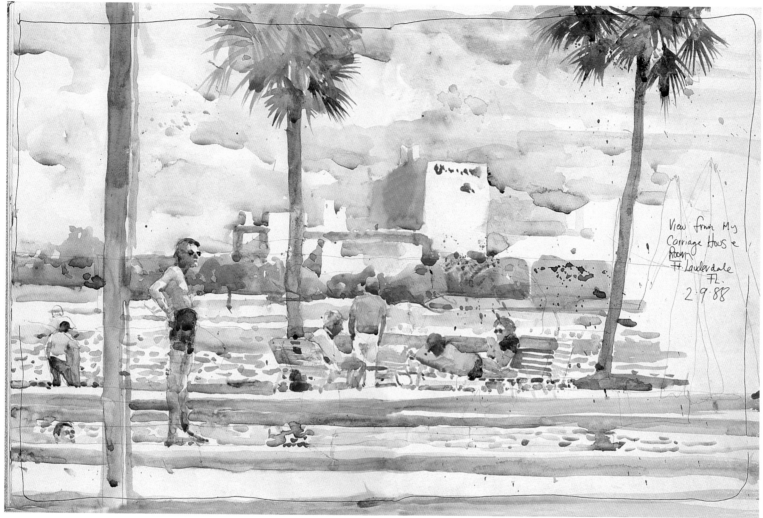

View from My
Carriage House
Room
Ft. Lauderdale
FL
2·9·88

Create a Path for the Eye

Never make a conscious focal point in your painting. You want the viewer's eye to travel through the whole painting rather than being stopped by a focal point. Each area in your painting should be complete in itself with lost and found edges, intense and muted color and varying tonal-values.

I painted the standing man first—I always try to capture specific gestures. He became a focal point I didn't intend. Find where I tried to lead the viewer's eye away from him, locating points of interest throughout the painting.

Ft. Lauderdale, Poolside

Adding Value Variations to Your Shapes

Don't paint specific, minor value variations you see within dark shapes. Keep the dark shape's identity— the value you see when you squint. I often mix two colors on the paper within my darker shapes, so even though I'm aiming for a single value, minor value variations always happen. Paint the value identity with your first try; there's no time for glazing when painting outdoors. Mid values usually dry lighter, so paint them darker than you see.

Don't look for light and shadow on mid to dark local colors. Light and shadow are (usually) only important on light-valued subjects like the two people in the left foreground.

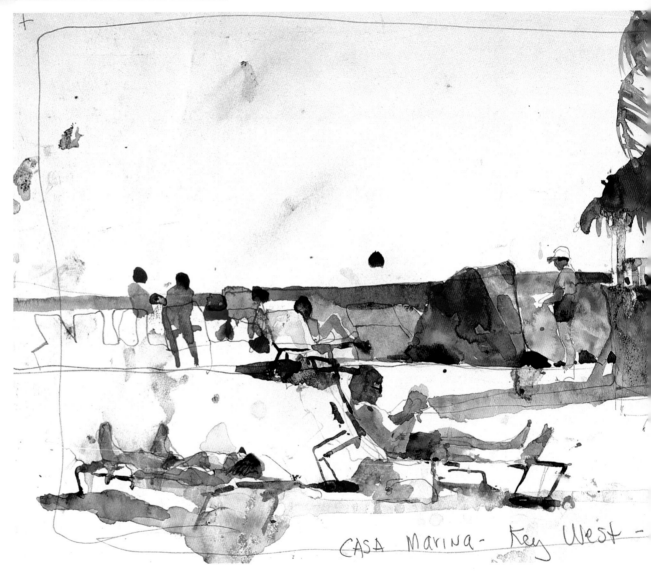

CASA Marina- Key West -

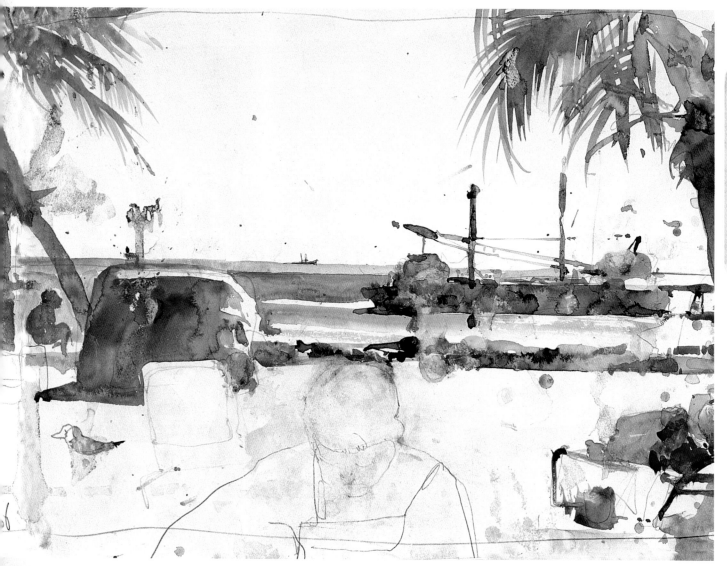

Use Both Pages of Your Sketchbook
I used a 9" x 12" (23cm x 30cm) sketchbook, working across the gutter, using both pages. I drew the lower left for a light or mid-value painting without putting in an initial dark value for comparison. The dark in the upper right is balanced with a darker lower-left to middle foreground.

Casa Marina, Key West

Seeing Local Color-Value

Local color-value is the inherent value and color of an area regardless of the effects of light and shade. If you're unaware of the local color of the things you're painting, your darks will be too light and your lights too dark, creating washed-out colors resulting in a mid-valued, bland painting.

> ### Creating Success
> *The key to successful painting? Concentrate first on shapes, local value and edges. Then think of color.*

Subtle Light and Local Color

Chatham Light was painted with a hazy sun—ideal for seeing both subtle light and shade as well as local-color. If seeing local-color is new to you, make color-value studies while squinting, using flat shapes with no light or shade. Once you see and can paint the actual local color of all the elements in your painting, you can make changes as I did when I lightened the upper section of the lighthouse.

Chatham Light

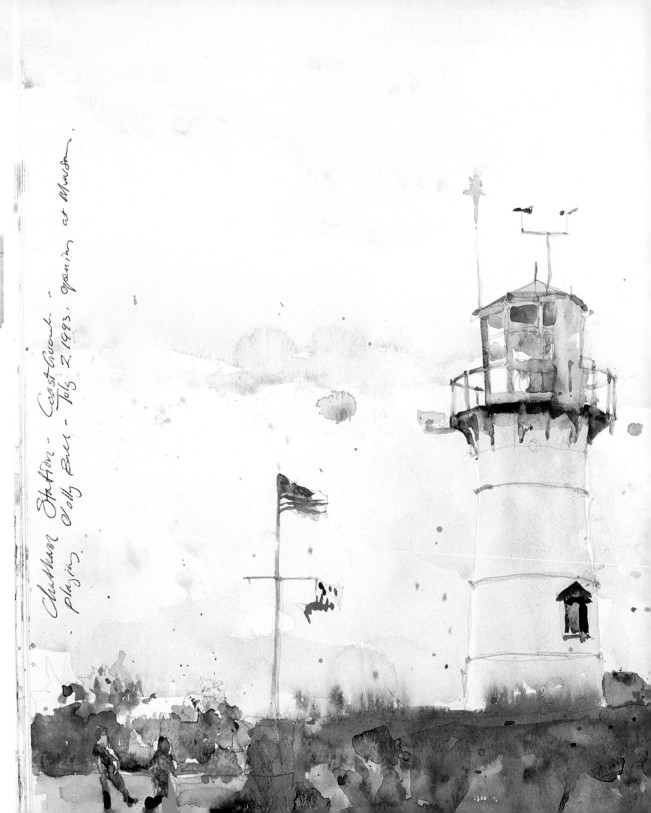

Variation Creates Interest

The trick to painting is to have large, simple parts mixed with smaller parts of careful detail. This is the idea behind the principle of lost-and-found edges as well as hard edges and blurred edges. Don't paint your detail with a tiny brush and very dark lines. Study the flagpole and the upper section of the light and antenna. I vary my tones and edges, including lost-and-found edges. The bands around the tower are kept light so I won't destroy its overall lightness. I added the dark window on the tower to balance with the dark chimney and window in the house as well as the red and blue in the flags.

I don't always paint what I see—the top of the tower was actually painted black. Edward Hopper would probably have painted it black with good effect. Sorry, but there's no "right" way to paint a picture. The principle of lost-and-found edges is also valid; it just depends where and how each individual painter applies it.

Seeing Light and Shadow, Not Detail

Some subjects have overwhelming detail that can't be painted in an hour or two in your sketchbook. You need "the magic squint" and some sunlight. Squinting makes it easier to forget detail, and the sunlight will help you see light and shadow shapes as you're squinting.

Tonal-Values and a Limited Palette
I've used six tonal-values and a limited palette on these West German destroyers (see page 62—My Basic Palette). Make a value scale of six tonal-values. My tonal-value differences are subtle; try making a value scale and match the sections in my painting to it. Don't worry if you're not sure, because we all see color and tonal-values differently. My one wish is that you always use "the magic squint" and see shapes first rather than details.

West German Destroyers, Barbados

West German Destroyer and other ~ NATO Excercises ~ Barbados 4·21·86

How It Was Done

First, the drawing was completed. I lined up the upper tip of the bow with a place on the super-structure of the ship using a plastic ruler. Then I estimated the distance from the bow to the superstructure. If you get your bow-to-super-structure relationship correct, you'll have main-tained accurate perspective.

The whole destroyer was done with one wash of Cerulean Blue, making the wash a bit darker as the hull met the dock. When dry, I added the shadow shapes and the adjoining tanker. The pic-ture was done late in the day, with backlighting. Painting such a complicated subject in flat light-ing is a poor idea because there are too many small forms and complicated shapes. The bright sun simplifies.

Using Wet Paints

Your paints must be wet, not damp, but moist and tacky, like oil paint. You will also need a spray bottle to keep the colors moist. Practice painting "color shape people" in your studio, using the figures in my paintings as a reference. I always paint my darks and shadow shapes first, leaving white for my lights or adding my light skin tones last, when my shadows are dry. Concentrate on shape, making each figure unique, and never plan for a second wash.

Paint in Sections

Finish each person or section before going on to an adjoining section. I paint each section as a unit; I started and finished the distant bushes, water, shadow, cast shadow shapes, building and pool side before painting the pool and foreground people. When painting outdoors, always paint from dark to light, never from light to dark. This will ensure that you maintain the correct values in your painting.

The Water Club

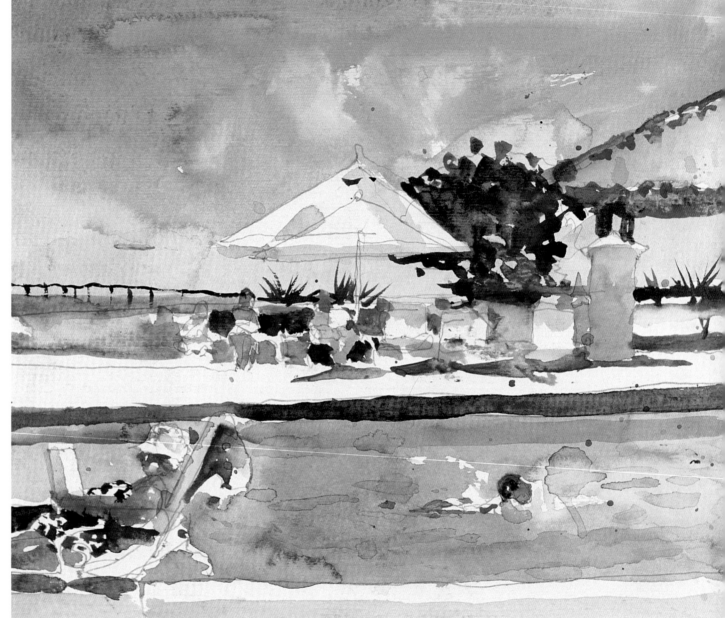

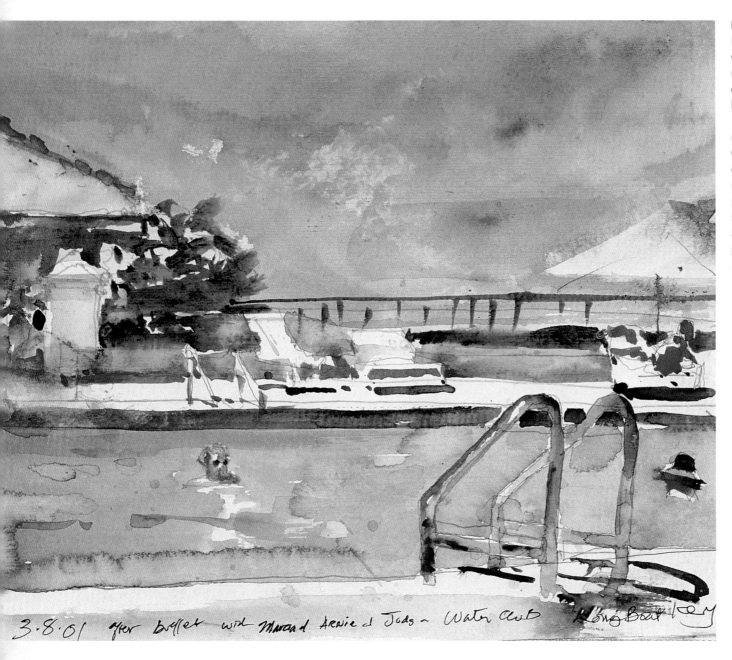

3.8.01 *after buffet with Maud and Arnie d Judg~ Water Club* *Klong Boat*

Painting Blues

I didn't paint the pool's water well—you'll notice watermarks and blotches. I don't mind water-marks, as they're a natural part of watercolor, but even if I did mind, any corrective measures would have only made the water worse.

Pools always seem to be an inviting Mediter-ranean blue, regardless of the sky's mood. I used Cerulean Blue in the sky and Cerulean and Pea-cock Blues and a touch of Cadmium Yellow Pale mixed on the paper with the Peacock Blue in the pool. A pool can have many confusing ripples, so it's best to keep the water simple with an over-all single tonal-value. Some minor variations are good. The swimmer on the left was splashing, so I kept some white paper around him.

Sketchbooking—A Fresh Perspective

Painting in my sketchbook is a holiday—one that helps me see from a fresh point of view. This is good for me and provides me with peace of mind. I worry that my watercolor painting could lapse into the comfort of skill and the painting of clichés.

Try to paint your scene when it's unique and shows a particular time of day with a sense of the weather. Paint it just the way the sky and the sea appear as you're painting. Always paint six distinct tonal-values when it's a bright day. An overcast day may have only three or four tonal-values, but they must be distinctly different.

Capturing an Event

Leaving a camera behind in favor of a sketchbook has forced me to draw and paint things happening around me with immediacy and clarity. First I painted the grass and path; I usually paint the sky last. Painting the sky last worked well for this painting. I used the sky to create darker shapes to illuminate the light-valued parachutes. I also waited until the sun was low enough to get some sparkles on the ocean. Try for a sense of a "happening" with parachutes going this way and that and dots for spectators. Worry about subtleties of color and tone in your lights, but exaggerate and simplify intense color in your darks.

Torrey Pines, La Jolla, California

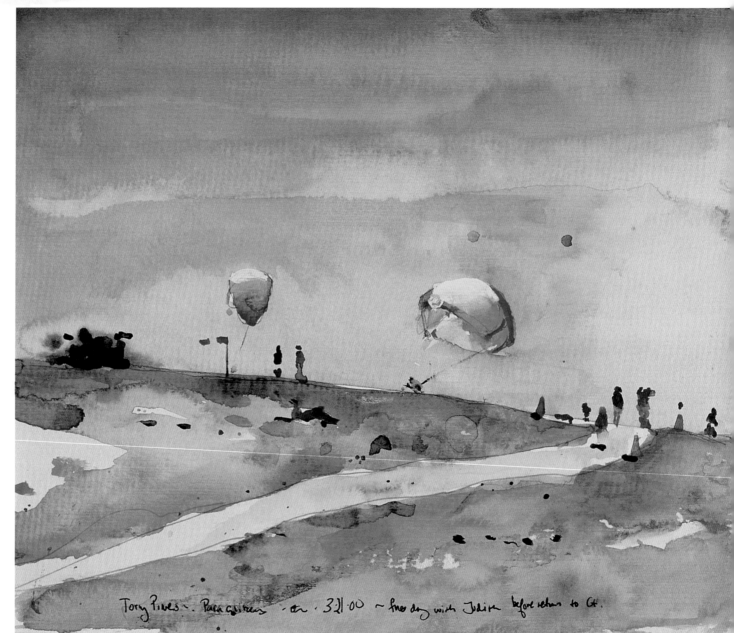

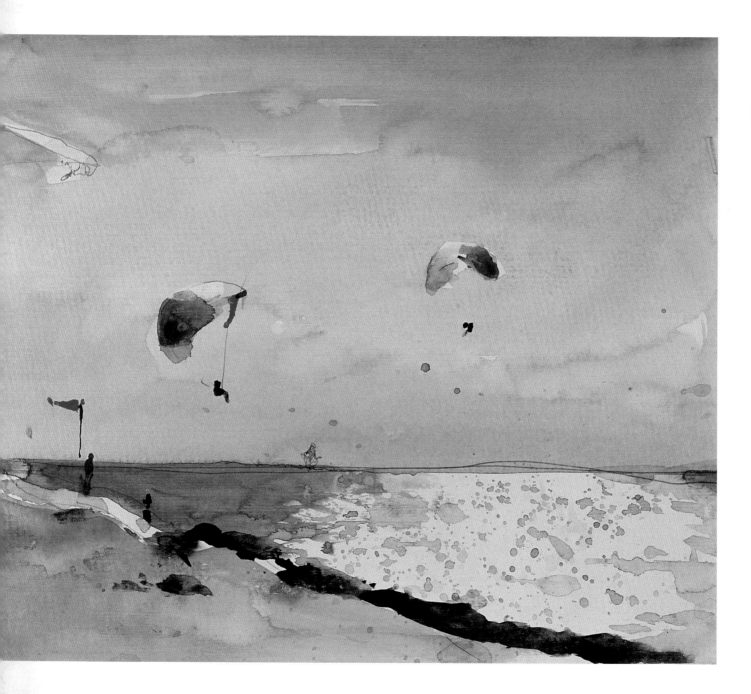

Sketchbooking helps
me keep a fresh
point of view.
❀

Painting Surf

Surf is confusing because it's constantly moving. When painting surf, always paint a darker shape first; never compare light values (the water) with white paper. Don't paint anything, light or dark, without comparing it to an adjacent dark. I kept my eyes on the rocks with my peripheral (out-of-focus) vision on the water. I wanted to understand the relative tonal-value of all of the surf, without all of the confusing waves, as well as the rocks. I saw that the rocks are dark and the surf is light.

Squint to Find Your Darks
Always compare confusing light and mid-tonal-values with a dark you're sure of. Squint and paint your darks and mid darks first, then paint and compare your lights and mid lights with the darks you've painted. Never paint your lights and mid lights first.

Bob Wade Painting, Cape Schanck, Australia

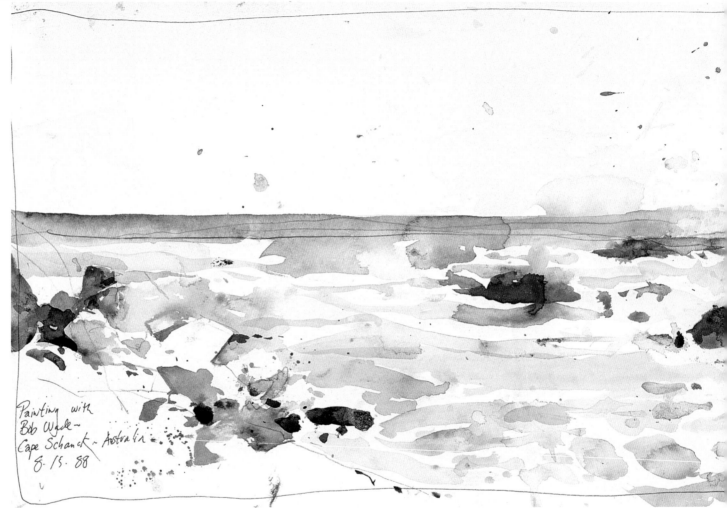

Painting with
Bob Wade ~
Cape Schanck ~ Australia
8. 15. 88

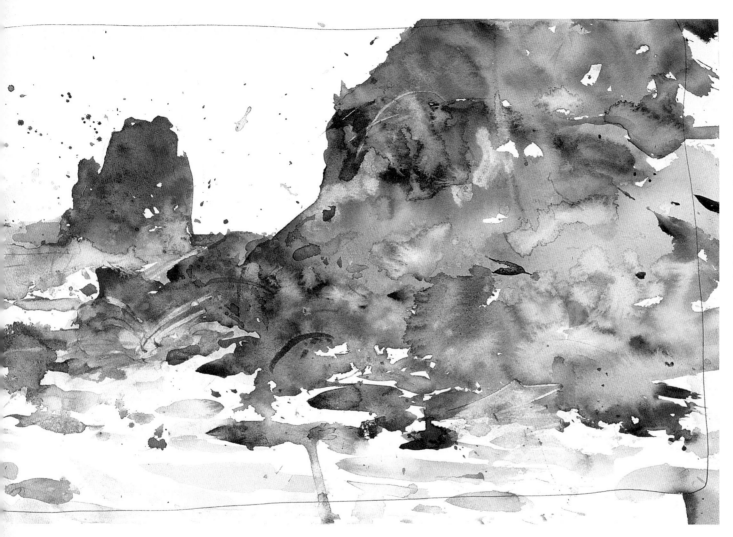

Painting Water Wet-in-Wet

My sketch is a vivid remembrance of painting with my friend on the coast of southeast Australia, but I'm not pleased with the surf. It has too many hard edges, and perhaps I shouldn't have painted some of the small rocks where the ebbing surf met the main rock. When you're painting on location, you're going to paint things that you'll wish you would have left out. Corrections are usually a mistake. It's good that I didn't try to lift out the rocks; at the time they were good darks contrasting with the white, ebbing surf.

It's best to paint a large, dark mass (the rock formation) wet-in-wet on the paper as long as you have plenty of wet pigment—and I mean wet—on your palette; it must be like oil paint. You'll also need enough water. Your mix should be like thick soup—not watery.

Try Ultramarine Blue and Burnt Sienna and Burnt Umber in your mix. Use a no. 12 sable brush and start where the rocks meet the light and paint back, keeping your brush on the paper. If you start running out of paint, get some more to complete the rock, but try not to go back into what you've painted; let the paint and water finish the rock. If it dries too light, you can rewet the paper and apply more paint. Drop the water—don't paint more soupy pigment into the dampened paper. Make swatches first to see what the paper will accept and what ratio of water to paint you need. Be patient. This is hard.

Painting Waterscapes

Don't complete the drawing in the foreground and dock—it's OK to leave out parts (I often do). Don't plan to follow your drawing exactly when you paint, but change shapes and draw with the brush, often ignoring the drawing and correcting as you go. Be careful not to fill in all of your drawing lines. If the line represents an apparent tonal contrast, that's fine, but if you've made a line between two compatible tonal-values, you should ignore the line.

MATERIALS

Pencil
Mechanical or repelling pencils (.07mm and .09mm HB)

Brushes
Nos. 2, 4, 6 and 8 sables

Paints
Bamboo Green • Burnt Sienna • Cadmium Red Light • Carmine • Cerulean Blue • Cobalt Blue • Hooker's Green • Olive Green • Raw Sienna • Viridian

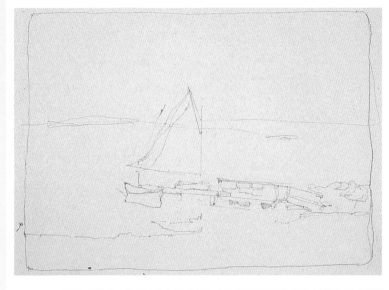

1 Draw the Skiff

Use a single line to tie the image into the picture border. Draw the skiff and its reflection as one; this will remind you that the skiff's water line will be lost. I had to correct my drawing in the sail, but don't worry about erasing too much. It's often better to correct with paint on "soft" paper like Fabriano, my usual choice. (This demonstration is painted on a very rough-textured but delicate paper made by Schut in Holland that is not available in the United States.)

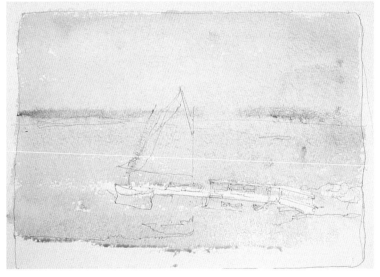

2 Paint the Sky and Water

This scene is very foggy, so paint the sky and water as one shape with diluted Cobalt Blue, Raw Sienna and a touch of Carmine mixed on the paper. Leave some white paper for the dock and light values in the water. While the paper is still wet, use Cobalt Blue and Raw Sienna for the distant land. Adding diluted color wet-in-wet is a bit tricky. Work the colors out on your mixing area first, keeping the identity of the blue and Raw Sienna—don't mix them completely. You should be able to see traces of the original colors. Use just enough water to get a value just a little darker than you want; then with only a damp brush, paint the distant land.

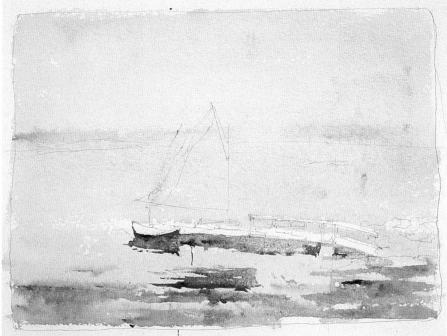

3 Paint the Foreground

Paint the foreground marsh grass a warm green wet-in-wet using Olive Green. Experiment—Hooker's or Bamboo Green or Cobalt Blue mixed with a little Raw Sienna might work, too. Use a little Carmine on the right.

4 Paint the Grass and Dock

As the paper is drying, add more grass. Wait until the paper is completely dry before painting the top of the skiff side (shear strake) with Hooker's Green and Viridian, Cerulean Blue and Raw Sienna. Start at the shear strake, which is the darkest, then lighten the color as it works down to the reflection's lower boundary. Add a bit of darker color but don't paint a dark separation between the boat and its reflection; continue right into the dock without stopping. Paint the dock with Carmine, Raw Sienna and Cerulean Blue. Paint the hard-edged reflection of the sail using Burnt Sienna and Cadmium Red Light next to the sea grass. Don't use wet-in-wet for water reflections.

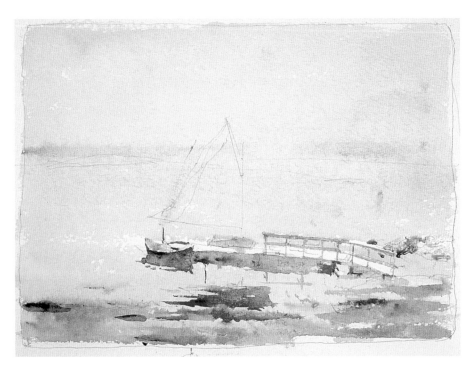

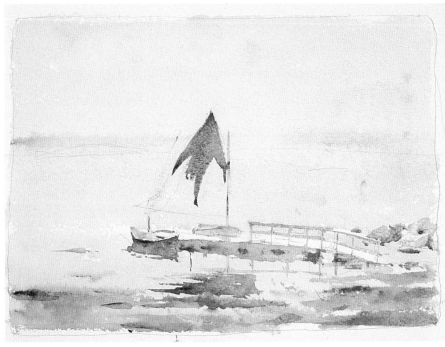

5 **Paint the Boat Hull, Dock Railing and Rocks**
Use Carmine, Cerulean Blue, and Raw Sienna to paint the boat hull. Paint the dock railing with Carmine, Cerulean Blue and Raw Sienna. Mix the colors on the palette, but only briefly—you want color and subtle tonal-value variations in these thin forms. Add individual colors wet-in-wet in spots, but make sure your tones don't get spotty. This will take practice; mix just enough water to find the right tonal-value without being too watery, adding them wet-in-wet. The rocks on the right are Cobalt Blue, Carmine and Raw Sienna.

6 **Paint the Boat**
Paint the boat's mast with dark and lighter versions of Raw Sienna. Paint a mast shape with clear water, then accurately drop in slightly diluted Raw Sienna. This is a good way to paint any thin form like the mast or railings. Start with a slightly diluted color and paint the thin form, then add color and minor tonal-value variations, wet-in-wet. Add some more details like the post reflection on dry paper and just a few darks in the dock—remember, less is more—so keep the dock as simple as possible with few added darks.

Starting from the peak, paint the sail with Carmine and Cobalt Blue. If the drawing is unsure, correct it with your brush. Make sure you have enough Carmine and blue on the palette's mixing area. Work the colors together with a light touch; don't combine the Cobalt Blue and Carmine completely. Don't lift the brush once you've started forming the peak of the sail with the brush tip. Press the brush to the paper at least halfway to the ferrule until you run out of paint. Mix a new combination of Carmine and Cerulean or Cobalt Blue while your colors are still wet.

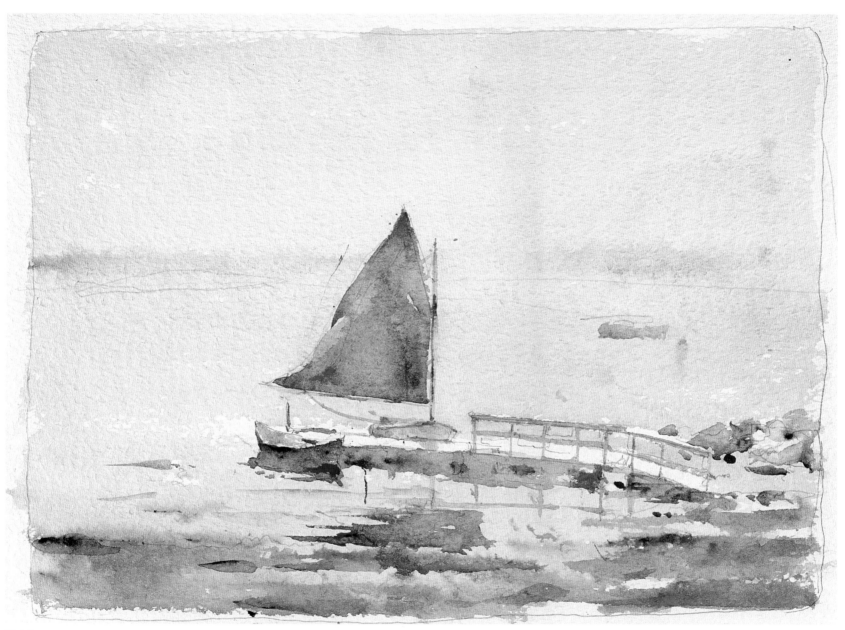

Finish

I'm not delighted with this painting, which was done from a photograph. I wasn't as spontaneous as I might have been if I were working on the spot. Sadly, I was too concerned with making a mistake. I did what we must never do—I worried about failure and didn't take the chances needed to make a good painting. Worrying about failure usually results in a mediocre painting.

Conclusion

I hope you've enjoyed looking at these pictures, which span most of my years as a watercolor painter. Hopefully you've learned a bit.

At first it seems that there's too much to think about all at once, but as you paint you'll find certain steps, like controlling edges, becoming automatic. The hardest step is learning the best ratio of water to paint. Points to keep in mind: The darker the area, the more paint and less water. Paint from the damp paint supply rather than the mixing area when painting middle to dark tones and intense lighter colors. Keep the value identity in your local tonal-values, avoiding minor value variations.

Finally, practice picture making in your sketchbooks, always designing the page with a complete thought. Don't worry about composition but always lead the viewer's eye through the painting.

Good Painting and Keep it Rich!

Charles Reid

Dordogne

Sarlat-La Caneda ~ Sept. 27.02
Dordogne ~ Charles Reid

The best in art instruction and inspiration is from North Light Books!

Here's all the instruction you need to create beautiful, luminous paintings by layering with watercolor. Linda Stevens Moyer provides straightforward techniques, step-by-step mini-demos and must-have advice on color theory and the basics of painting light and texture—the individual parts that make up the "language of light."

ISBN 1-58180-189-0, hardcover, 128 pages, #31961-K

This gorgeous book shows you how to colorfully combine your favorite nostalgic items like hand-made quilts, china and lace with small songbirds or kittens, then bathe them all in beautiful sunlight. You'll find guidelines for developing any heart-warming memory or curious story into a lovely composition. Each step is shown through invaluable mini-demos with finished examples.

ISBN 1-58180-181-5, hardcover, 128 pages, #31948-K

Bert Dodson's successful method of "teaching anyone who can hold a pencil" how to draw has made this one of the most popular, best-selling art books in history—an essential reference for every artist's library. Inside you'll find a complete system for developing drawing skills, including 48 practice exercises, reviews, and self-evaluations.

ISBN 0-89134-337-7, paperback, 224 pages, #30220-K

Susan Harrison-Tustain casts new light on a favorite subject among watercolorists. Artists will learn her unique priming method, along with other techniques for creating vibrant colors, realistic textures and lively light. Included are three complete step-by-step painting demonstrations and 14 mini-demos.

ISBN 1-58180-389-3, paperback, 128 pages, #32444-K

These books and other fine art titles are available from your local art & craft retailer, bookstore, online supplier or by calling 1-800-448-0915 in North America or 0870 2200220 in the UK.